5/05

IMAGES
of America
ST. LOUIS
FIRE DEPARTMENT

WITHDRAWN

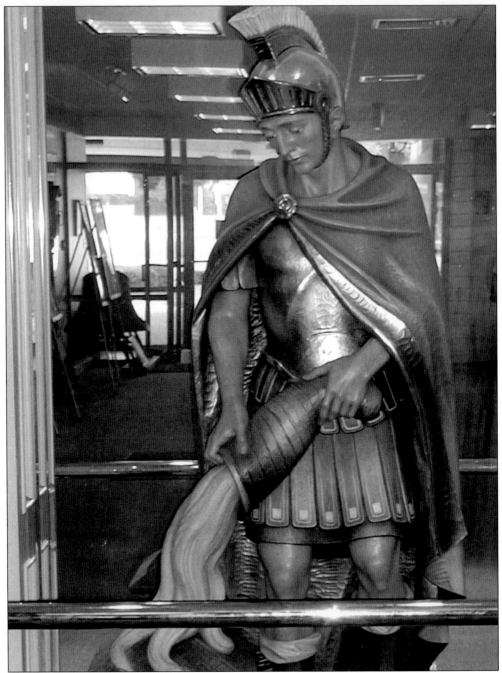

A statue of St. Florian, the patron saint of firefighters, greets visitors to the St. Louis Fire Department headquarters and museum.

On the cover: Engine Company 21 with its 1871 Ahrens 2nd size 700 gpm steamer in 1883. This company was originally located at 3407 Market St. A new firehouse was built for the company in 1965 at Vandeventer and Forest Park Blvd. The new quarters housed engine Co. 21, Engine Co., 29 Hook and Ladder Co. 5, and Rescue Squad 1.

IMAGES
of America
St. Louis
Fire Department

Frank C. Schaper and Betty Burnett

ARCADIA

Published by Arcadia Publishing,
an imprint of Tempus Publishing, Inc.
Charleston SC, Chicago, Portsmouth NH,
San Francisco

Printed in Great Britain.

Library of Congress Catalog Card Number: Applied For.

For all general information contact Arcadia Publishing at:
Telephone 843-853-2070
Fax 843-853-0044
E-Mail sales@arcadiapublishing.com
For customer service and orders:
Toll-Free 1-888-313-2665

Visit us on the internet at http://www.arcadiapublishing.com

Herman, the fire dog of Engine Co. 30, is pictured here in the 1970s.

CONTENTS

FOREWORD

From its early beginning, the village-town and then the city of St. Louis was protected by citizens against the ravages of fire.

First came the appointment of fire wardens with their buckets followed by the volunteer fire companies and finally in 1857 the paid St. Louis Fire Department was established.

As the city of St. Louis grew to be a major city in the United States, so too the St. Louis Fire Department grew to be one of the finest fire departments in the nation, and it is still recognized as a first-class department that has brought progress and innovation to the fire service; for example, the scaling ladder and the quint concept.

Throughout the years the one constant factor has been the dedication of the firefighters— whether volunteer or paid, men or women, black or white—to provide a service to those whose life and property were endangered by fire.

Through conflict and turmoil, civil unrest and war, prosperity and poverty the men and women of the St. Louis Fire Department have always answered the call for help from those who live, work, and visit our fine city.

We are justifiably proud of and salute all of the St. Louis firefighters past, present, and future!

Chief Neil J. Svetanics
St. Louis Fire Commissioner
1986–1999

ACKNOWLEDGMENTS

Bob Pauley, historian for the St. Louis Fire Department and curator of its museum, is one of those rare individuals who loves to share his knowledge. We could not have done this book without his enthusiastic support. While most of the photos are from the fire department's archives, many are from his personal collection. He is a city treasure. We also appreciate the support of Chief Sherman George and everyone who stopped by Bob's office to ask how we were doing.

Thanks, too, to Noel Holobeck, St. Louis historian at the city's Main Public Library. His interest in the project and suggestions for sources were much appreciated.

Frank would like to thank his wife, Toodie, and daughter, Heather, for their loving support and cooperation. He would also like to thank his former Chief Neil Svetanics, for the use of his reference library and his valuable memory of department history. Thanks, too, to his friend Andy Tracy who encouraged him to write. Thanks to Hank and Barb Schaper for their photograph contributions and support. Betty would like to thank Loretto and Warren Kleykamp for their many kindnesses.

We both thank Bill Newberry and Michael Burnett for sharing generously of their technical expertise. Photos are from the Paul Nauman collection and used through the courtesy of the St. Louis Fire Department Museum, Robert Pauly curator. Photographers include William Greenblatt, Terry Buchheit, George Beaumont, and Dave Parshall.

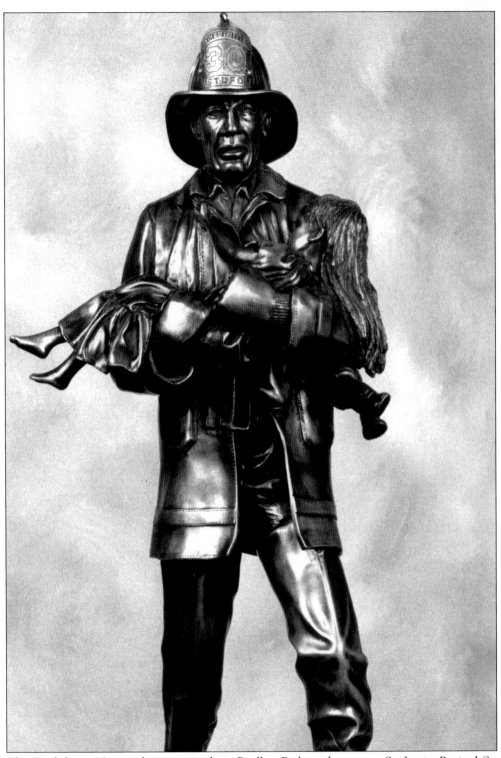

The Firefighters Memorial statue stands in Poelker Park in downtown St. Louis. Retired St. Louis firefighter Robert P. Daus sculpted the ten-foot tall bronze statue.

INTRODUCTION

"Where're you goin', Cap'n?" hollered Isaac Sturgeon. Scarcely pausing, Captain Thomas Targee of Missouri Fire Company No. 5 shouted, "We're going to blow up Phillip's store!" On he ran, carrying a keg of powder.

Sturgeon later said, "That was the last I ever saw of poor Targee." Just moments after Targee entered the building a tremendous explosion leveled it. He was killed instantly, blown to bits by the explosive charge. The Great St. Louis Fire of 1849 had claimed its third life, but Captain Targee's act of bravery ultimately saved the city from total destruction.

The fire had started the evening before on May 17, 1849 at 9 p.m. The steamer White Cloud somehow ignited at the foot of Cherry Street. By the time the firemen arrived, sparks had set ablaze other boats moored at the levee. The flames quickly spread ashore. The fire gained headway, overwhelming the volunteer fire department of nine hand drawn engines and hose reels.

By the next morning, the fire had taken hold of the city. It spread in all directions and the entire business district seemed doomed to destruction. The venerated Catholic cathedral, the first cathedral built west of the Mississippi, lay right in the path of the flames. The demoralized fireman cried out, "What can be done?" and desperate officers of the various fire companies decided to use powder to stem the ravaging flames.

Targee took part in blowing up six buildings in succession. The sixth building, Phillip's Music store at Second and Market Streets, was the culminating point of the conflagration and the one that cost Targee his life.

The fire was stopped but not before it destroyed 430 homes, burned twenty-three steamers and nine flatboats and barges. The devastated city lost the Republican, the Reveille, and the Evening Gazette printing offices, the post office, three banking houses and other property amounting to $2,750,000. The fire was a terrible blow to the economy of St. Louis but within a span of two years the city rebuilt and regained its commercial prosperity.

Captain Thomas B. Targee was not the first St. Louis fireman to lose his life in the line of duty nor would he be the last. Fred Turnbull was killed in 1838 and three firemen, Jesse Baker, Jacob Weaver, and Anson Kimbal, were all killed on April 17, 1841. Targee's death on May 18, 1849, was followed by the death of Matt Burns on June 15, 1851.

These men, all from the volunteer fire companies, made the supreme sacrifice, giving testimony to their courage and bravery. Their exemplary firefighting feats were never forgotten.

During the nineteenth century, the city of St. Louis experienced tremendous growth. By the mid-1800s, the "Gateway to the West" boasted a population of 140,000 people. Building construction using wood and bricks was at an all-time high and business was booming. Fires increased along with the population. The volunteer fire department was hard pressed to keep up with them. Additionally, the rowdiness of the volunteer firemen was causing more harm than good. The rivalry between the various companies was fierce. It became so intense in the

early 1850s that rioting was a common occurrence at their fire scenes. It was time to establish a paid fire department. In 1857 the City Council passed an ordinance establishing a paid municipal fire department. Mayor John Wimer appointed Henry Clay Sexton as the first fire chief. On Monday morning, September 14, 1857, the new fire department began operations, ushering in the era of horse-drawn steamers.

The St. Louis Fire Department has taken pride in the fact that its members always faced fire's destruction head-on. Consequently, throughout its long history of battling thousands of fires, there have been many more victories than defeats. When fire destroyed five downtown blocks during the Penny and Gentle fire of 1900, Mayor Ziegenhein said, "The saving of the German-American Bank was one of the prettiest bits of fire fighting I ever saw."

As the city of St. Louis continued to grow, so did the fire department, which eventually topped out at fifty-six engines and twenty-three hook and ladders on April 1, 1926.

City fireman loved their fire horses but those beautiful animals could not compete with the new technology arriving on the scene. After the turn of the century, horse-drawn steamers were replaced by motorized equipment across the country. Fire Chief Charles F. Swingley purchased the first automobile used in the fire department in 1905, and by March 26, 1927 the St. Louis Fire Department was fully motorized. The fire horses were no more and a page in the history of the St. Louis Fire Department was turned.

The department's heroic fire fighting continued with ever more sophisticated equipment through the years and that history has been captured within the pages of this book. Resourcefulness, innovation, gallantry, bravery, and courage are dramatically depicted in this pictorial history of the St. Louis Fire Department. Now join the authors and explore in this book the rich history of the St. Louis Fire Department—a department that was destined for greatness.

Frank Schaper
September, 2003

One

THROW OUT
YOUR BUCKETS!

Fifty years after its founding in 1764, St. Louis was little more than a fur-trading outpost on the Mississippi River. In January of 1811, a volunteer fire department was organized with Pierre Didier as captain. As late as 1818, the department still had no equipment, except for a few buckets for either sand or water. Fire wardens were appointed to patrol the town, and they were responsible for alerting the volunteer firefighters in case of fire. The system worked fairly well until the town outgrew it. Steamboats turned St. Louis into a major port, with extensive docks and rows of shops, tenements, factories, and warehouses. Volunteer fire companies vied with each other for the chance to be first at a fire. There was little organization and even less technique. A disastrous fire almost destroyed the city in 1849. Within a decade, pushed by insurance companies who could not cover the losses from another catastrophe, the city agreed to a professional organization of the fire department.

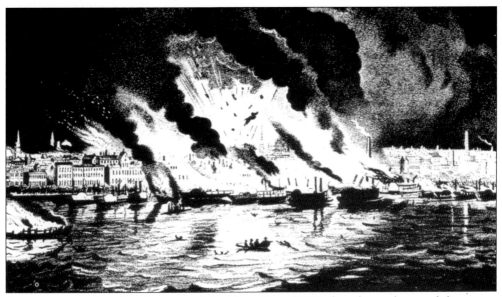

An unknown artist painted a scene of the Great Fire of 1849 that almost destroyed the city.

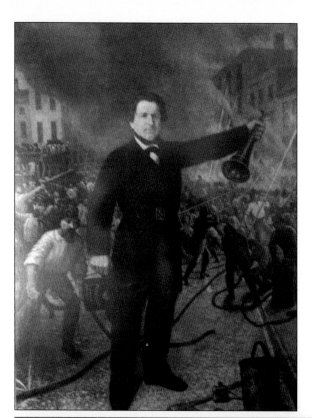

Thomas Targee was the hero of the Great Fire of 1849.

CAPT. THOMAS B. TARGEE
MISSOURI FIRE CO. #5
HERO OF
"THE GREAT FIRE OF ST. LOUIS"
MAY 17TH & 18TH, 1849
KILLED IN THE LINE OF DUTY
DURING ITS EXTINGUISHMENT

The plaque commemorates his bravery.

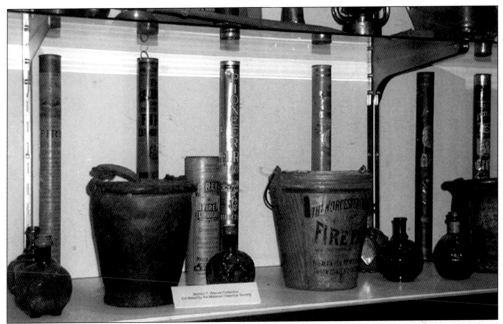

When an alarm of fire was sounded, the cry "Throw out your buckets!" could be heard throughout the town. Leather fire buckets, such as those pictured above, were the chief firefighting apparatus of the day. The first fire buckets used in St. Louis were made by shoemakers and hand-sewn from the best tanned sole leather. These buckets, along with glass fire extinguisher "hand grenades," helmets, lanterns, and other items are on display at St. Louis Fire Department Headquarters Museum on loan from the Missouri Historical Society.

Fire department officers in the nineteenth century carried speaking trumpets. These ornate trumpets were made in various sizes of painted tin or shining brass. It was said that commands shouted through these trumpets could be heard for several blocks. After an especially difficult fire, the trumpets might be used as drinking mugs. The mouthpieces were removed and replaced by a cork, making a rather formidable drinking vessel.

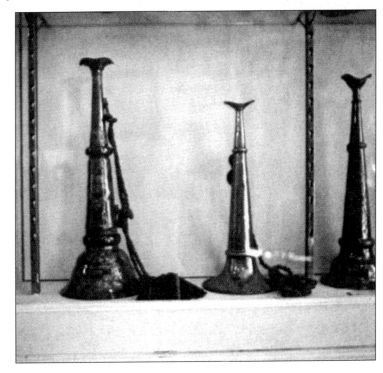

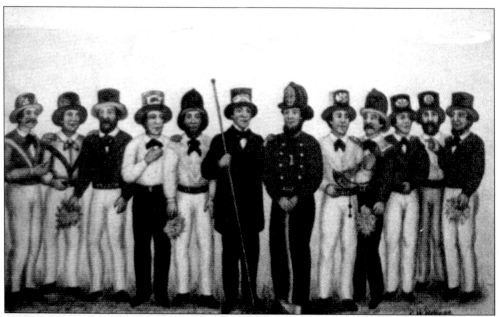

The impeccable volunteer fireman's uniform was a prized possession. Each uniform was bought at the volunteer's own expense, and cost was no object, such was the pride volunteers took in their dress. Pictured are the parade uniforms, with a different style for each company. Later, the mayor insisted all firemen wear the same uniform design. Confusion during a fire made it imperative that firemen wear distinct and recognizable clothing.

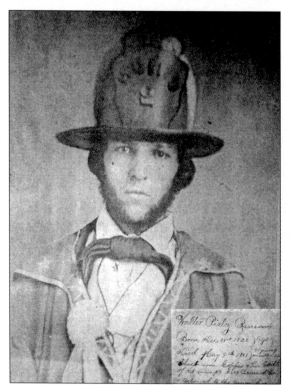

Walter Ransom, a volunteer with Union 2 Company, sports his impressive fire helmet and parade garb.

An 1836 John Agnew 1st class Philadelphia-type suction hand engine was driven in the parade of the Veteran Volunteer Historical Society on April 30, 1889.

The Dinkey engine of Union 2 Fire Company was bought in 1851. It was the pride of the city.

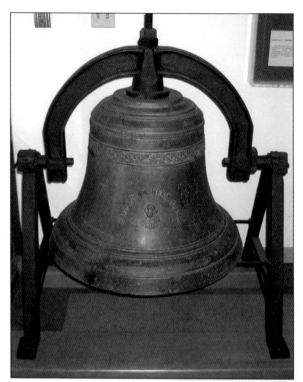

The bell used by the Phoenix volunteer company is on display at the Fire Department Headquarters and Museum. There were nine other volunteer companies: Central, Union, Washington, St. Louis, Missouri, Liberty, Franklin, Mound, Laclede, and Lafayette. The competition among them was fierce.

The Phoenix Company is portrayed in a painting at the Fire Department Headquarters. They are gathered around their Dinkey engine. The bell hangs in the tower above the engine house.

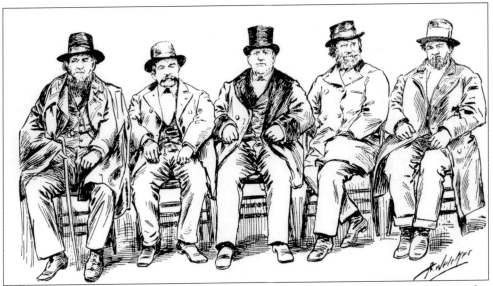

The first five members of the St. Louis professional fire department were, from left to right, George W. Tennile, John W. Bame, H. Clay Sexton (chief), Richard Beggs, and Jacob Trice.

The fire department's first steam engine, a three-wheel Latta, arrived in East St. Louis from Cincinnati in December of 1855. There was no bridge spanning the Mississippi River at the time, so the ten-ton engine was gingerly hauled across the frozen river while spectators held their collective breath. Union No. 2, on Washington between Seventh and Eighth Streets, was the home of this engine for years.

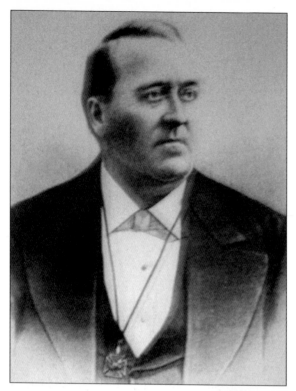

The city's first fire chief was H. Clay Sexton. President of the volunteer Mound Fire Company, he was Mayor John Wimer's first choice for Chief Engineer of the new St. Louis Fire Department. One of his most important jobs was to cool the rivalry among volunteer companies. He appointed the chiefs of two competing units to join his company as assistants and won the support of all the old companies, except Liberty, which continued to operate independently until it was burned out. When military rule came to St. Louis in 1862, Sexton was fired for being a Southern sympathizer, although he denied it. He was reinstated after the Civil War. His reputation as a firefighter was such that he was offered the position of fire chief of the Chicago Fire Department after their great fire of 1871. Although the salary was twice his St. Louis salary, he declined and served St. Louis until 1885.

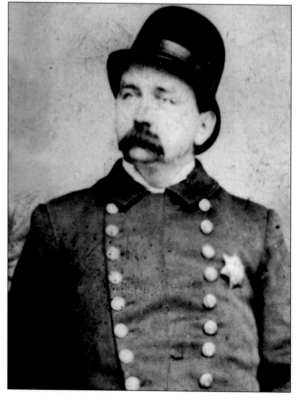

George N. Stevens served as fire chief 1862–1867. Here he is pictured in his police uniform. During the Civil War, St. Louis was a divided city, with passionate rebels and rabid Unionists frequently in conflict. In September 1863, a plot by "incendiaries" was discovered. Using Greek fire (a bottle of flammable liquid with a long wick), rebels burned at least 60 boats along the riverfront.

Chief A. C. Hull replaced Stevens in 1867. He was fire chief a mere five months. His sash identifies him as part of the Central Company and he holds a speaking trumpet.

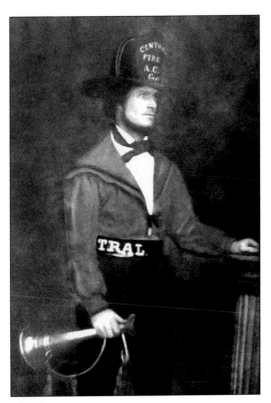

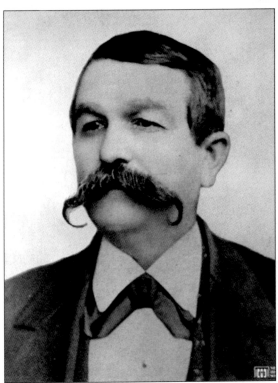

In May 1867, John W. Bame was appointed fire chief. He remained in the position for two years.

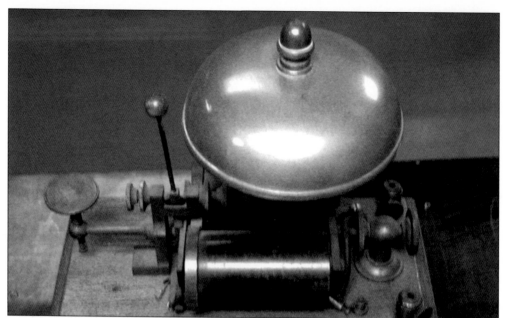

Firemen used telegraph keys to signal the need for dispatching fire apparatus. They also signaled when they had completed their assignments.

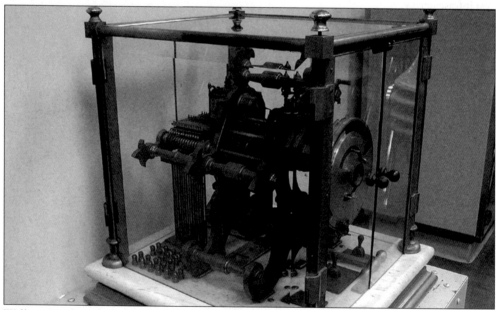

William F. Channing, a medical doctor turned inventor, patented the first fire alarm telegraphy system in 1855. A short time later, an amateur telegrapher named John Gamewell, bought the patents from Dr. Channing. Gamewell saw that there was a profit to be made off the new invention. He gathered a group of investors and went about installing fire alarm systems across the country. By 1861, Gamewell systems were in place in several large cities, including Philadelphia, Baltimore, and St. Louis. By 1904, there were 764 fire alarm systems in the United States, with a total of 37,739 fire alarm boxes. The Gamewell system was discontinued in 1977 and replaced fully by radio and telephone.

Two

CHIEF SWINGLEY IN
COMMAND

1880–1910

St. Louis was in its heyday during the decades on either side of the turn of the twentieth century. The city proudly hosted the World's Fair in 1904, and Americans were dazzled by its grandeur. As the city grew up as well as out, the fire department ordered longer ladders, more powerful pumpers, and developed new techniques for reaching people trapped in high-rise buildings. Downtown businesses were well aware of the danger of fire. The first fireproof structure was the Commercial Building at 6th and Olive. Built of Missouri granite, it had an iron infrastructure. St. Louis' highest fire during this period broke out on Saturday, February 19, 1910, on the twelfth floor of the Title Guaranty at the southwest corner of 7th and Chestnut.

The bell hit—drop the chains! Firefighters scramble for their apparatus at Engine House 1, 2413 McNair Ave c. 1880.

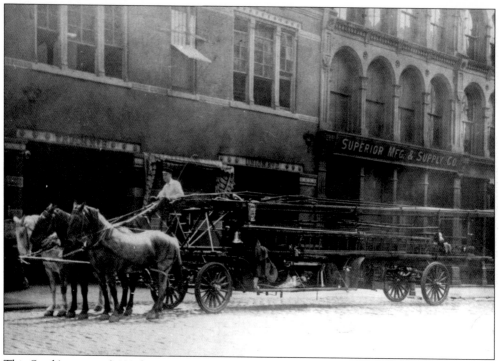

This Steck's patented 100-foot Babcock aerial hook and ladder truck was delivered in December 1892. Costing $3,800, it carried 312 feet of ground ladders and became Hook and Ladder No. 8.

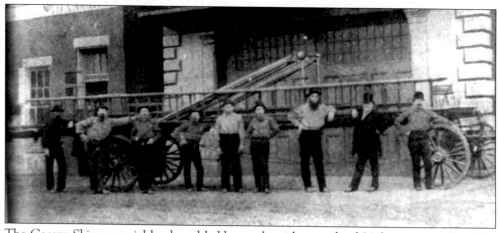

The George Skinner aerial hook and ladder truck, with a reach of 84 feet, was purchased in 1874 for $2,800. It was assigned to Hook and Ladder 3 at 216 N. Seventh St.

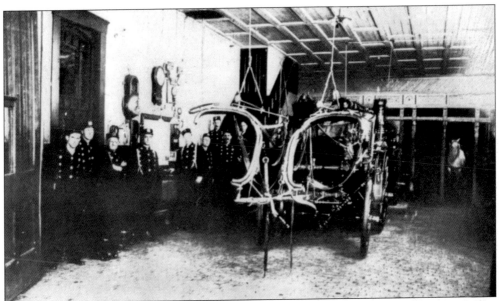

Fire horses were trained to get into harness in three seconds after the alarm sounded. The harness was hung over the two outside horses and the center horse had to be backed in. A few quick snaps here and there and they were off. The horses and their handlers practiced the routine every day. Paddy Lavin, a long-time horse handler, claimed that the animals could recognize their Morse code signal alarm just as rural folks recognized their "ring" on a party line.

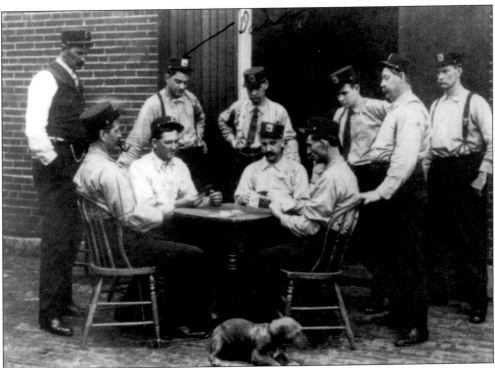

A typical afternoon at the firehouse after the morning chores were done finds the men playing cards while waiting for an alarm to sound.

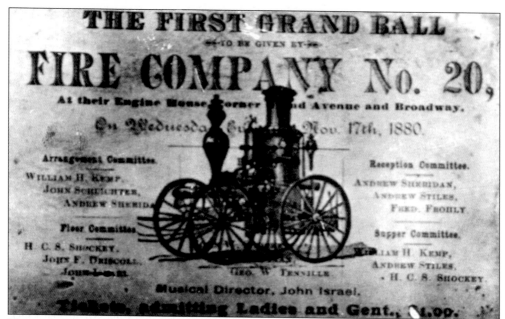

This ticket to the Fireman's Ball from 1880 guaranteed the holder an evening of fun—music, dancing, and supper, too, for $1 each.

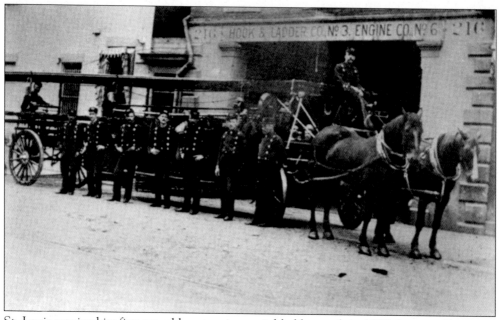

St. Louis received its first turnable extension aerial ladder truck in 1883. It was a Hayes 85-foot manual hoist purchased from American La France Engine Co. and assigned as Hook and Ladder No. 3. The truck was destroyed at a general alarm fire on Seventh Street just north of Washington on January 28, 1902.

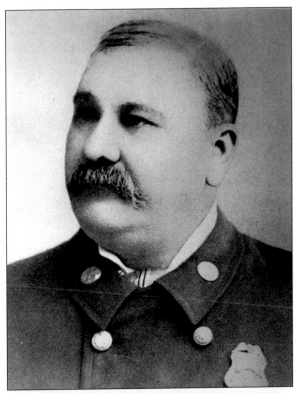

John Lindsay was promoted to fire chief on May 1, 1885. During his ten-year command, the department continued to grow. Chemical Engine 4 was put in service and four hauling wagons were purchased to deliver hay, grain, and other supplies to firehouses. As more fire companies were established, it was necessary to rewrite the running cards—these cards told firemen which alarm their company was on. For the first time, these cards showed a fourth alarm assignment. Lindsay established a pension fund for firefighters. An early certificate is below.

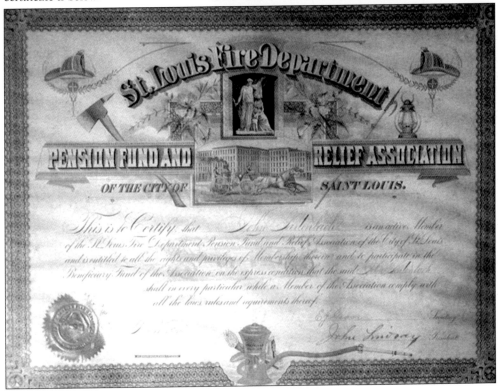

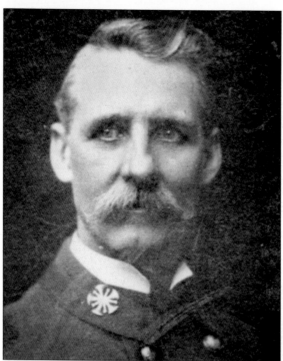

Charles E. Swingley became fire chief on May 15, 1895, and held the post for almost 20 years, making him the longest serving chief in the department's history. Chief Swingley organized the Fire Department into eight fire districts. New fire companies continued to be organized, and by 1901 the department boasted 37 firehouses. At the time, the fire department headquarters moved to Room 104 in the new City Hall. In August 1914, Swingley was appointed Director of Public Safety.

The horses were fed oats twice a day, at 5 a.m. and 2:30 p.m. and were given hay and water in between. Every morning the straw in the stables was changed and the blankets aired. "They bought better blankets for the horses than for the men," Paddy Lavin claimed, "but maybe that was only fair." Without the horses, the engines were almost useless. One year the horses came down with an epizootic disease and for several days the men labored to push and pull the engines to fires themselves. Chief Swingley ordered fire horses removed from service after fifteen years. He also ordered the washing down ("plugging off") of horses with cold water after a hard run, stopped.

Hundreds of residents in the vicinity of Engine House 19 at 1200 St. Louis Ave. contributed 50¢ each toward the purchase of this bell. Made of silver, bronze, copper, and brass, it cost $3,000 when it was cast in 1887 by L. M. Rumsey Manufacturing Co. of St. Louis. A bell tower was specially built for it. Sirens replaced bells around 1911, and in 1921, the bell tower was dismantled and the bell put in storage. Chief John O'Boyle rediscovered the bell in 1933, shined it up, and put it in a prominent spot in the fire department headquarters.

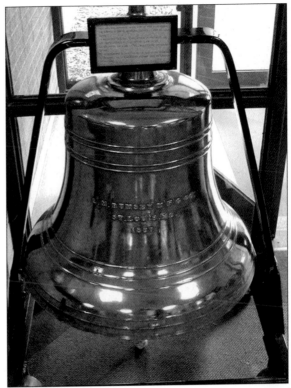

Engine Company 39 was located at 3945 Kossuth in 1892.

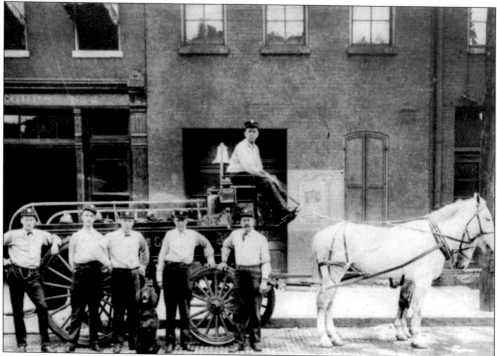

The city wardens were disbanded in 1874 and replaced by the Salvage Corps, established by the insurance underwriters to rescue insured property from fires. By 1893, three units were operational across the city.

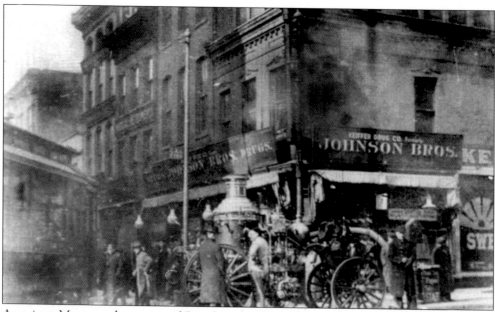

American Metro at the corner of Broadway and Franklin in 1897 works around the trolley tracks at a downtown fire.

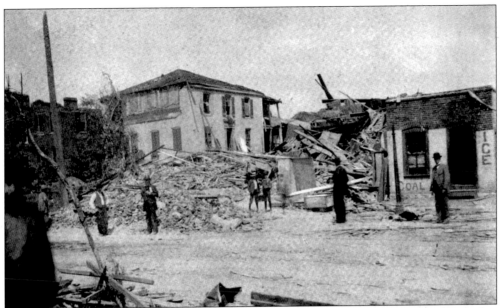

Nearly one third of the city's fire alarm system was destroyed in the devastating cyclone that roared through the city on May 27, 1896. Wires, poles, alarm boxes, and other instruments were ruined. Fires broke out all over the city after the tornado hit, but without working alarms, fire companies didn't know where to go. Trucks struggled through blinding rain, debris-clogged streets, and sparking wires. All the Salvage Corps and firemen patrolled the city, rescuing the trapped. Engine Co. 7 at 1304 S. Eighteenth St. was destroyed (above), although the hay bales in the loft were left intact. The photo below shows the company before the tornado.

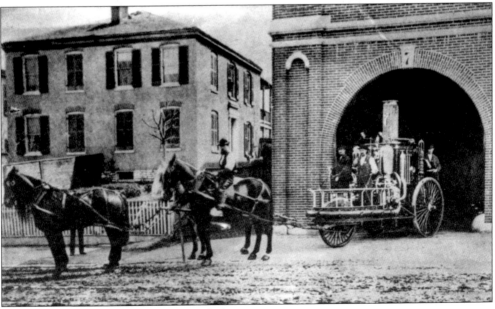

Engine Co. 7 as it was before the tornado hit.

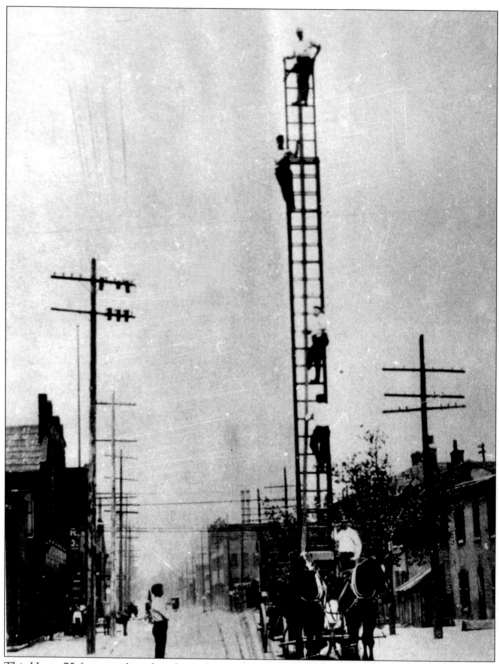

This Hayes 75-foot aerial truck is drawn by two horses instead of the usual three. The truck carried 287 feet of ground ladders. It was rebuilt and ran as hook and ladder No. 7 from 1909 to 1926.

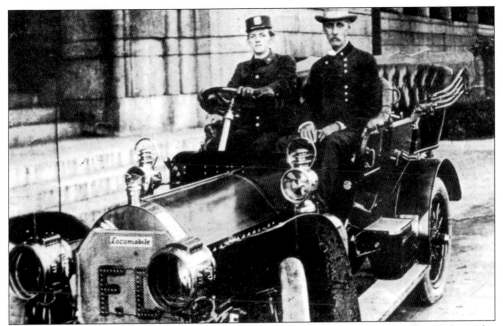

The first official motorized car in the St. Louis Fire Department was a 1905 Locomobile, 20 hp touring car purchased by Chief Swingley. He said, "There is a limit to a horse's endurance and also a humane limit to which a horse should be driven. It required three horses to do my work, and they were replaced every three or four years . . . Now, with the automobile, you . . . simply crank your machine and you are off. As to the relative safety . . . I think the automobile safer than the horse, running at a high rate of speed."

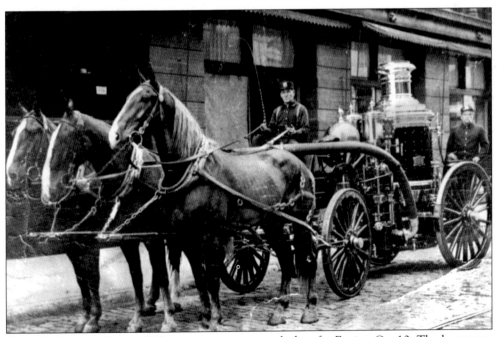

The 1904 Metropolitan, 1,000 gpm steamer saw much duty for Engine Co. 10. The horses are Blondie, Bismarck, and Jim.

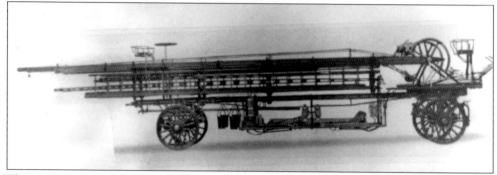

This American La France spring hoist aerial truck was purchased for the department about 1906. As hook and ladder trucks grew longer and traffic made maneuvering them more difficult, the problem of getting the rear of the vehicle around corners became acute. Shortly after 1850, an independent steering device for the rear wheels was developed called the tiller. Originally this was manipulated from street level. In time, the tillerman sat atop the truck and steered the back wheels from a steering wheel there.

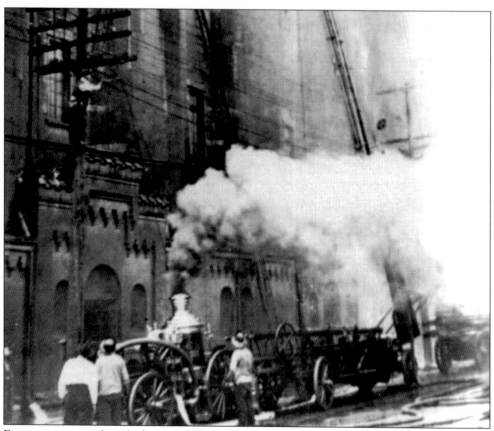

Fireman are at work with the American La France aerial in 1906. The location is unknown.

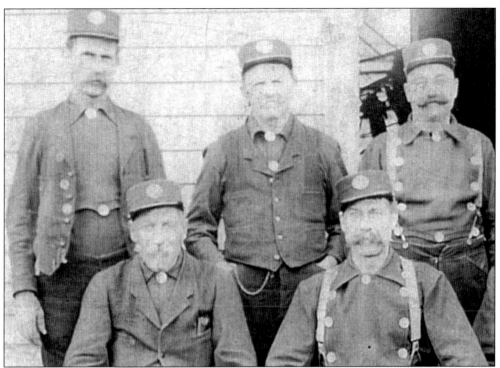

Men from Engine 37 in Baden (above) and from Engine Co. 4 (below) pose for a group photograph. Firemen made $67.50 a month in 1910 and from that had to buy their own food and uniforms. The heavy wool shirt with its two rows of white pearl buttons were the most expensive. To it was buttoned the shield which protected the chest. Then there were boots, raincoats, and helmets. Firemen bought their uniforms on time. "Every payday the man from the store came around," fireman Paddy Lavan explained. "We never got out of debt because by the time an outfit was paid for, we needed something new." There were no retirement benefits then and most men worked as long as they could.

Engine Co. 4

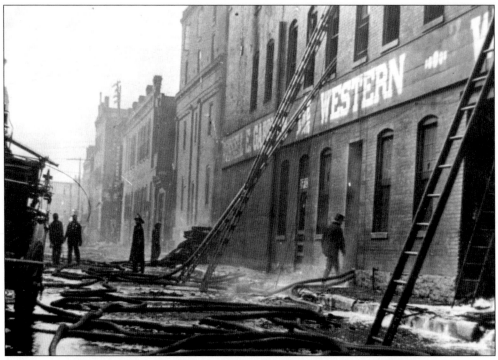

Hundreds of feet of hose are strung across the street after a fire at Western Wheel.

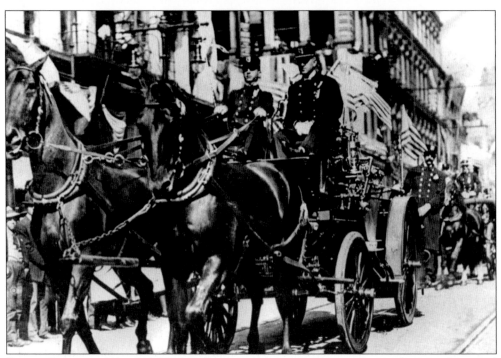

Engine Company 39's 1908 Metropolitan second size steamer was a combination hose and chemical wagon with deck pipe. Chemical wagons were manufactured in St. Louis by the Robinson Fire Apparatus Manufacturing Co. on 20th Street.

Three

GOODBYE TO
TOM AND JERRY

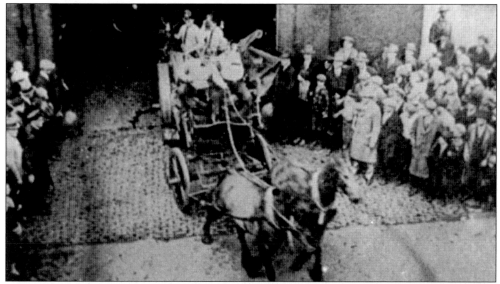

The last run of fire horses in St. Louis was made on March 25, 1927, from Engine Col. 25. Tom and Jerry dashed through a narrow lane in the crowd of several hundred spectators. They drew the hose carriage. Monk and Strawberry (still in the barn) pulled the steamer. The last run was made not to a fire, but for the benefit of newsreel photographers, who cranked away from points of vantage. Mayor Victor Miller supervised the ceremony, assisted by Fire Chief Charles Alt, other city officials, and the Fire Department band. The horses seemed indifferent to the program in their honor.

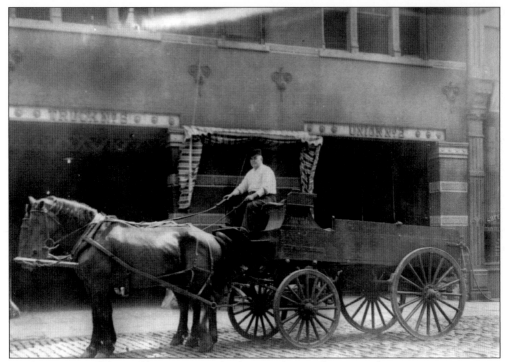

Hauling wagons delivered hay, grain, and other supplies to the engine houses.

In 1918 fuel wagons were introduced to bring fuel and motor oil to the fire scene for motorized equipment. Ten years later these units were responding to any alarm that had been in for twenty minutes and automatically on multiple alarms. By 1952, the department had four fuel wagons, all 1935 Studebakers.

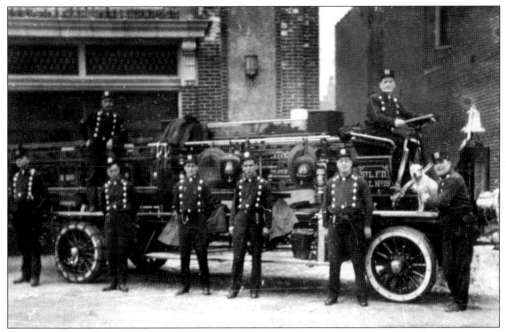

Engine House 18, located at 6810 Clayton Rd., was the first firehouse built for motorized vehicles. The crew shows off the first motorized hook and ladder truck in St. Louis, No. 19. Their mascot is just as proud as the men are.

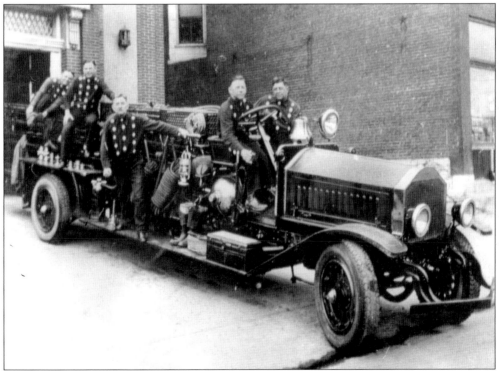

Engine Company 18 was located in the same firehouse as the hook and ladder.

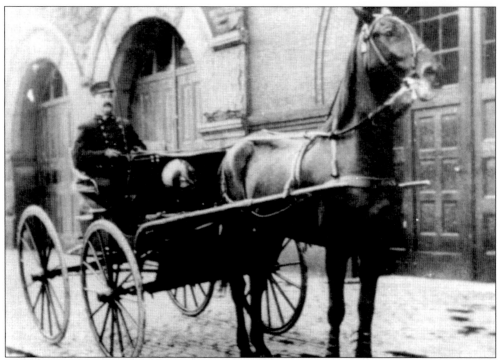

District Chief No. 4 in his buggy waits in front of Engine House No.12 in 1914.

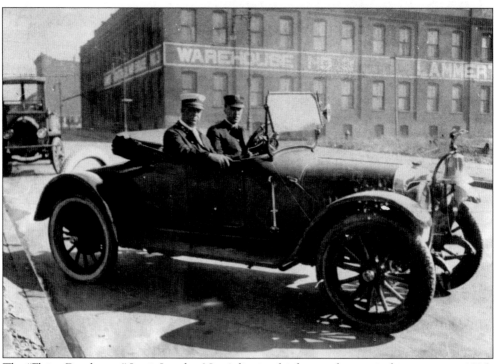

The "Flying Dutchman," Louis Jourder, No. 4 district chief, tours the area in his new car in 1915.

Frank E. Henderson, the fire department secretary, was appointed fire chief in August 1914, when Charles Swingley was promoted to the position of director of public safety.

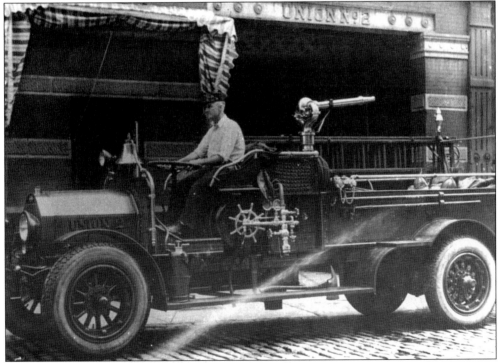

This 1917 Dorris Model IBW hose and chemical truck had a deck pipe or water cannon. It was assigned to Engine Company 40.

The fire department held a public demonstration September 18-25, 1916, at the Motordrome at Priester's Park, at Grand Boulevard and Meramec Avenue. The show, under direction of Chief Frank Henderson, benefited the Firemen's Pension Fund. During the production, a small city burned. The "city" consisted of three four-story and one five-story buildings, several cafes, theatres, churches, a department store, and two engine houses. The show began with about 100 men and women moving about on the streets. Suddenly a policeman turned in a fire. Seven pieces of fire fighting apparatus respond to fight the fire.

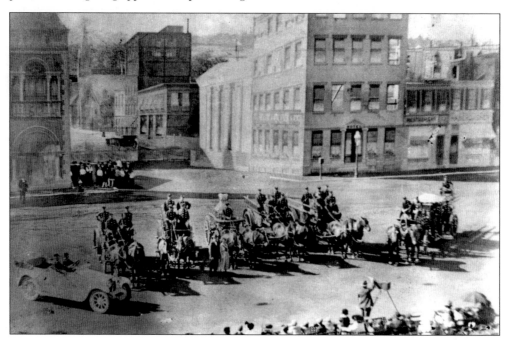

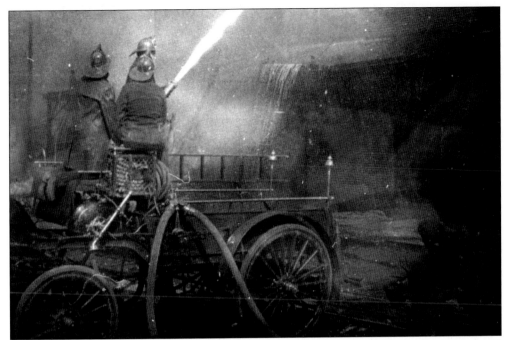

This combination hose and chemical wagon with a steel body and rubber wheels was equipped with a deck gun. It carried 20 feet of ladders, a 30-gallon chemical tank, 200 feet of 3/4" hose and 1,000 feet of 2 1/2" hose. It served Engine Co. 32 from 1904 to 1915, and then was transferred to Engine Co. 29. Here it is working a fire at the Western Feed Company.

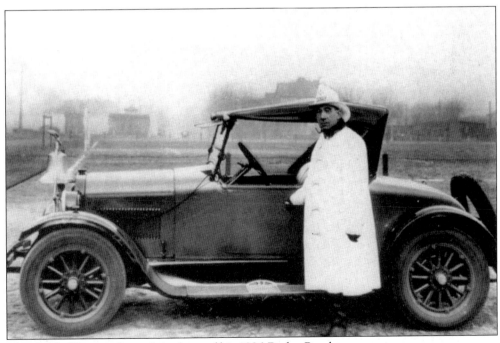

The chief of District 3 stands in front of his 1926 Dodge Roadster.

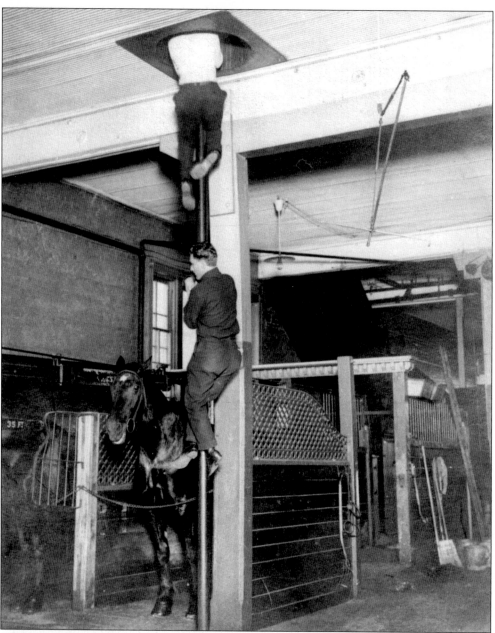

Firemen rushing to leave the station house for a fire slide down a pole. Legend has it that the brass pole was invented in Kansas City in 1889. Before that time, firemen took the stairs, often falling over each other in the dark, causing delays as well as injuries. The idea of sliding down a pole originated in St. Joseph, Mo., in the 1870s. Firemen there whittled a pole from a hickory log and installed it in their firehouse. Too many splinters kept the pole from being popular until a KC chief decided to make one of brass.

William Panzer served as fire chief from 1917 to 1925. In 1923 he played the part of Thomas Targee in a motion picture on city's history that was called *The Spirit of St. Louis*. The reviews were good.

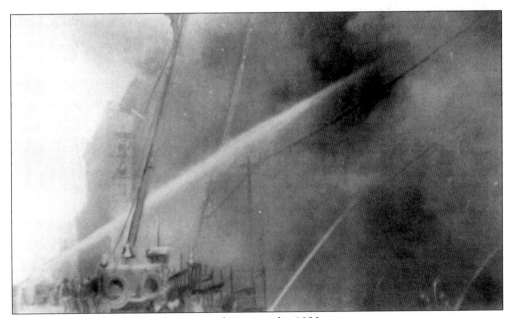

Firemen work a blaze in the downtown district in the 1920s.

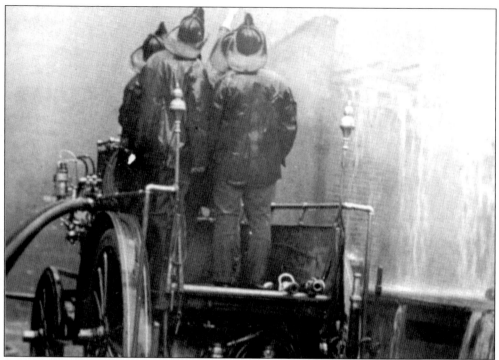

A hose wagon attacks a fire. Almost 12,000 hydrants were placed around the city by 1920.

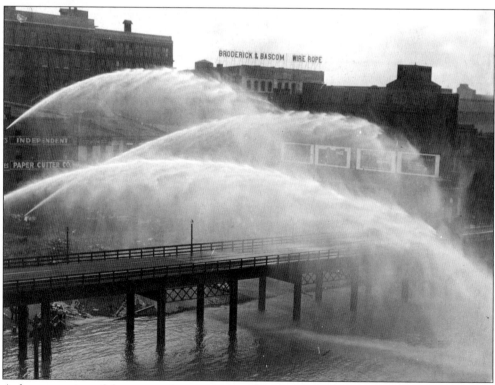

A demonstration of the power of pumpers wowed spectators in 1922.

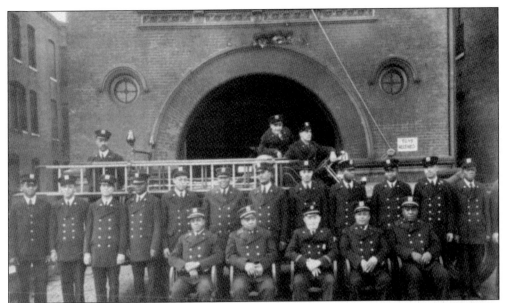

Black firefighters were first appointed to the St. Louis Fire Department on May 21, 1921. Aaron E. Malone, a black businessman, urged Mayor Kiel to make the appointments. Engine Company 24 at 1214 Spruce Street was reorganized as the first all-black fire company in the city. The first members were Claude R. Johnston, Lorenzo Graham, Henry Porter, Paul Farbush, Pearl Bishop, Walter Hill, Thomas Hill, and Frank Slaughter.

Engine house No. 32 was built in 1919 at 503 N. 20th Street.

Charles Alt was fire chief from 1925 to 1932, when he died of a strep infection. From a family well known on the South Side for public service, Alt was a policeman before joining the fire department in 1895. A genial man, he was exceptionally popular with firefighters, and the engine houses were draped in black when news of his death was flashed over the telegraph system.

It was against the rules to ride a sick horse to the horse hospital. Firemen caught doing so would be suspended and could have lost their jobs. Once the horse was healthy, it could be ridden home. A large stone horse's head decorated the front of the building.

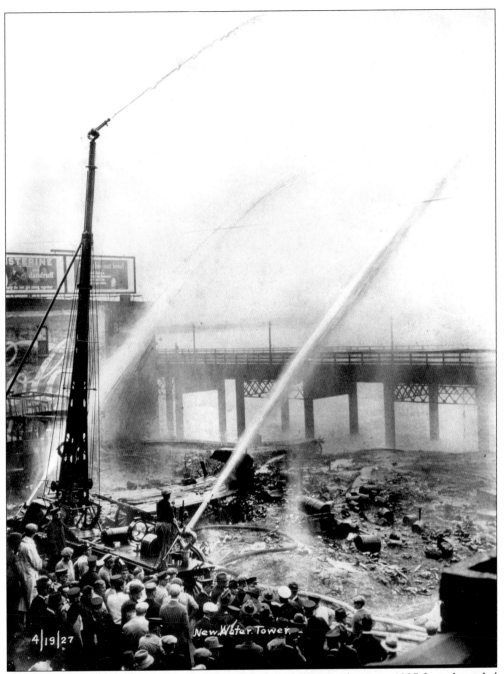

This aerial water tower was constructed by a fire department mechanic in 1927 from discarded odds and ends of obsolete equipment, saving the city some $20,000. The 55-foot apparatus, here giving a demonstration of its ability, was originally built in 1855 as a horse-drawn vehicle with two wheels. It was rebuilt as a four-wheel tractor with a tiller.

Engine Company 8 at 1501 Salisbury was destroyed in the devastating tornado of September 29, 1927. (It was rebuilt in 1928.) The station at 223 S. Newstead was also hit. Firemen throughout the city worked around the clock for six straight days after the tornado.

The Fire Department Training School was organized on July 16, 1926, with Joseph W. Morgan in command. First it was in a vacant warehouse on Spruce west of 12th Street. Later it was relocated to the third floor above Engine House No. 2 and the Repair Shop at 12th and Spruce.

Four
PASSING CHIEFS
1930–1950

During the grim days of the Great Depression in St. Louis, one-third of the city's workforce was unemployed. The homeless built shanty towns called Hoovervilles along the riverfront. With city income shrinking, the mayor cut the pay of firefighters and dismissed 100 men. To help out, firemen collected money, clothes, and food for the destitute. After World War II began in 1941, the fire department lost about ten percent of its men to the draft. The city's Office of Civil Defense recruited a large auxiliary force that promised to help in case of a major fire. Cities on both coasts feared an enemy attack, but St. Louis, located snugly in the middle of the country, felt relatively safe during the war years. After the war, the great migration to the suburbs began, and the city center began to decay. Six chiefs served during these turbulent political years; three died while in office.

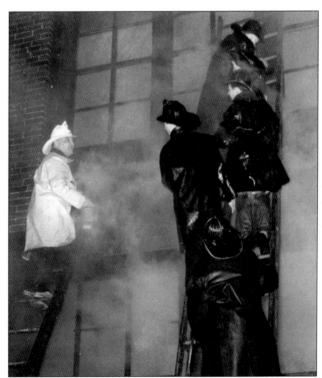

Chief Lawrence Cornoyer gives instructions to his men in a fire, c. 1940.

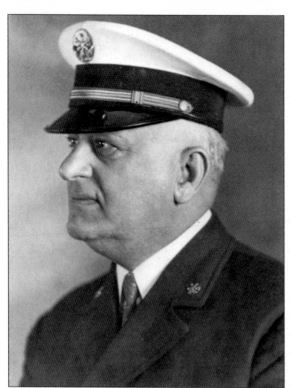

Frank A. Devoto became chief in July 1932 after 30 years' duty with the department. He had a solid reputation as a fearless firefighter. In a 1913 fire at a wallpaper company at St. Charles and 4th, Devoto was trapped on the second floor. The roof collapsed and a few minutes later, the floor dropped from under him. He jumped for a window frame and held on until he was rescued. There was a citywide outcry when Mayor Bernard Dickman asked Devoto to resign in 1933 because of conflicting politics.

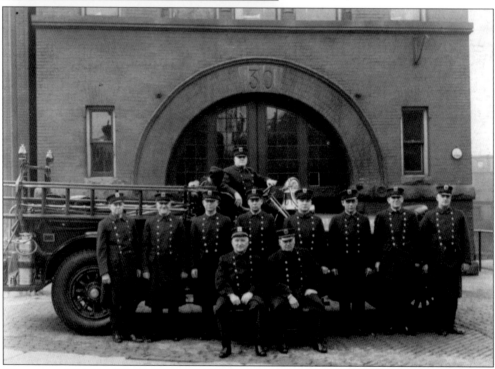

The men of Engine Company 30 at 5516 Vernon Ave. pose outside their station house in March 1931.

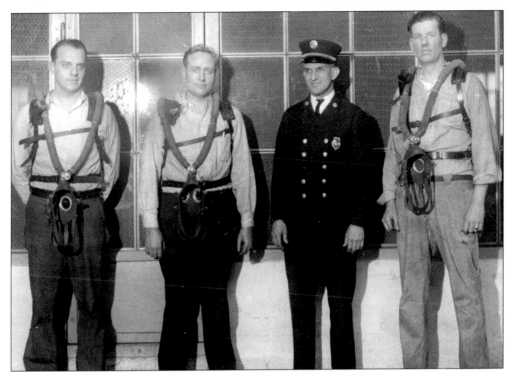

Self-contained breathing apparatus (SCBA) were introduced to the fire department in the early 1930s. St. Louis purchased 20 half-hour units, placing one with each hook and ladder company. District Chief Hugh Lyon stands with his crew.

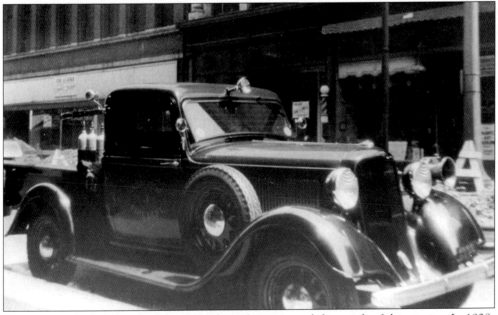

The success of inhalator crews in saving lives demonstrated the worth of this service. In 1928-29, the department responded to 75 calls with life-giving oxygen. This is a 1934 unit. In 1942 the inhalator cars left the fire department and were placed in the city's hospital division.

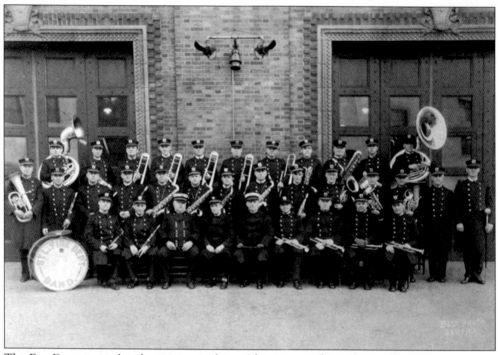

The Fire Department band was organized to perform in parades and at civic events.

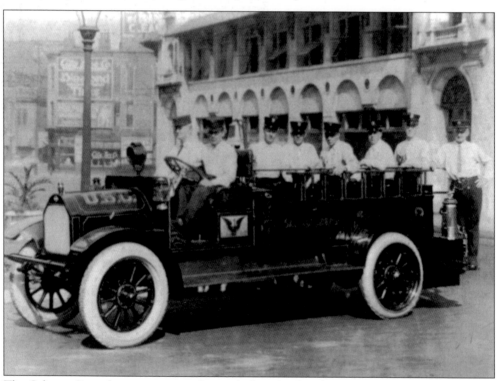

The Salvage Corps became motorized even before the fire department because it covered so much territory. The Corps served the city for 81 years, until it was disbanded December 31, 1955.

John J. O'Boyle became fire chief in 1933, coming from Engine Company 32. During his 31 years of active duty, he was usually the first one who went into a burning building. He frequently rescued those trapped by fire and once picked two babies from a crib moments before the crib exploded in flames. "He won't send his men anyplace he hasn't gone first to see if it's safe," one of his crew claimed. He died in office October 3, 1938.

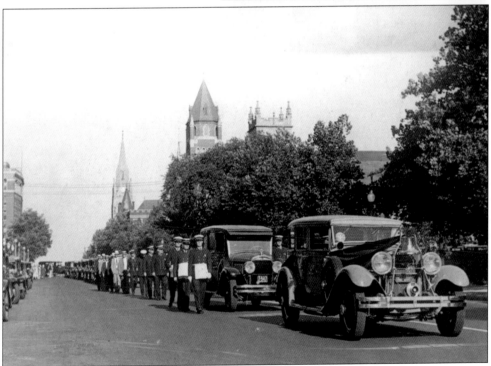

The line of cars in Boyle's funeral was long. Both civilians and firefighters marched alongside the procession.

The repair shop logo promised, "You call, we haul." Fire apparatus frequently broke down or was damaged in accidents.

The department's repair shop was supervised by a Master Mechanic. Beginning in 1910, tool and supply wagons were sent to the broken vehicle to make the needed repair. Most equipment was brought (or towed) to the repair shop, however, which still operates at Spruce and 11th Street.

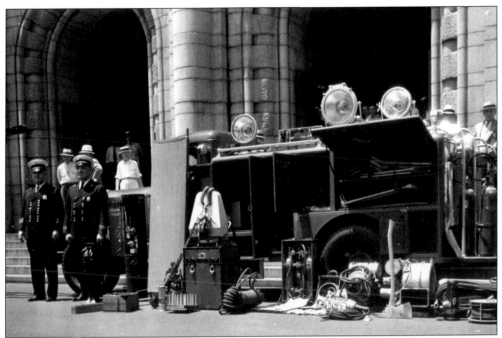

Rescue Squad No. 1 gave a demonstration of their apparatus and equipment in front of City Hall in 1934. The 1 1/2 -ton GMC chassis was wrecked in 1946.

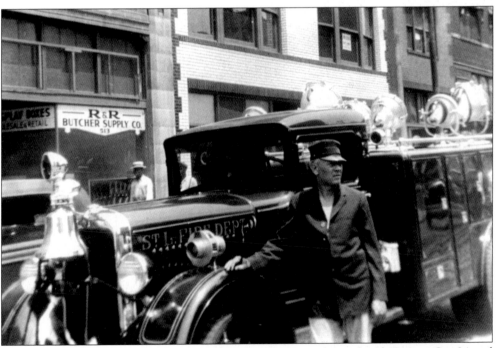

Rescue Squad No. 1 went into service May of 1934. It was housed with Engine Co. 24 and the water tower, located at 314 S. 12th Street. One of its functions was to free people trapped in wrecked automobiles or other machinery. It quickly became known for fast, efficient, and even heroic rescues.

Engine Co. 35 at Arsenal and Sublette has been in operation for more than 100 years.

Fireman Herman Vogel (center) poses with his jovial crew from Engine Co. 35.

Red fire alarm boxes were on almost every city corner in the years before 911 became the universal emergency number. This one was at Oak Hill and Morganford. During the 1930s, false alarms were a serious problem for the city, with about 12 turned in each week, mostly by children who ran and hid when sirens approached. One estimate claimed that each false alarm cost the city $416, a sum it could ill afford during the Depression.

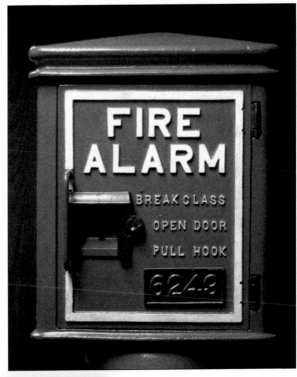

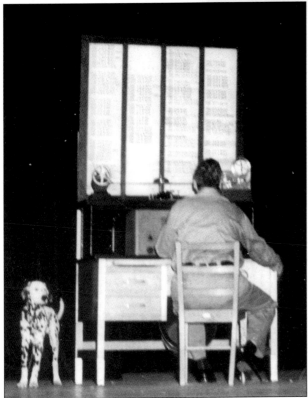

The jokerstand, an automatic alarm repeater, was command central for the fire department. Codes recorded which fire box had been pulled and how many pieces of apparatus would be needed. The dispatcher had to translate the codes immediately and send an alarm to the station closest to the fire. The system was efficient; it took only seconds to relay the information.

When Lawrence C. Cornoyer was a boy, he played around the engine house at 18th and Rutger. His idol was District Chief John Francis Barry, who was a hero in the Southern Hotel fire. "I never got over it," Cornoyer said when he was appointed fire chief in 1938, "and I never stopped wishing I could be like him." Cornoyer was descended from one of the first French families in St. Louis. As chief, he brought a dedication to the science of fighting and preventing fires. He served as fire chief until 1941, when he took a job as inspector in a defense plant.

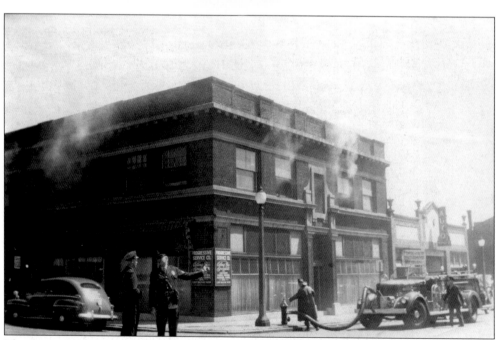

The driver for an engine company had to spot their apparatus perfectly to line up the "squirrel tail" with the fire hydrant. This scene is from about 1940.

Joseph W. Morgan was appointed chief in 1941. He became the first St. Louis chief to die in action when a building collapsed on him during a fire in 1943.

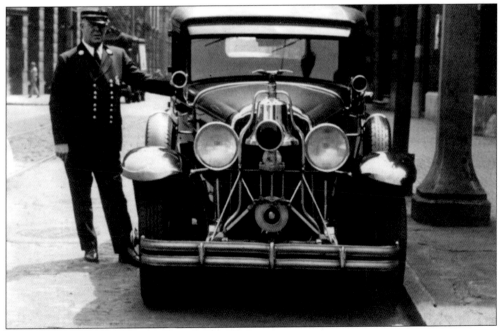

Chief Morgan's driver awaits the signal to depart.

Frank Egenriether succeeded Morgan as fire chief in 1943. He had previously been deputy chief.

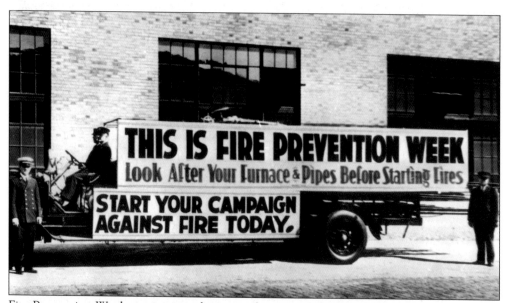

THIS IS FIRE PREVENTION WEEK
Look After Your Furnace & Pipes Before Starting Fires
START YOUR CAMPAIGN AGAINST FIRE TODAY.

Fire Prevention Week was instituted as part education and part public relations. It was very successful in involving children in the campaign against fires and helped reduce the number of false alarms.

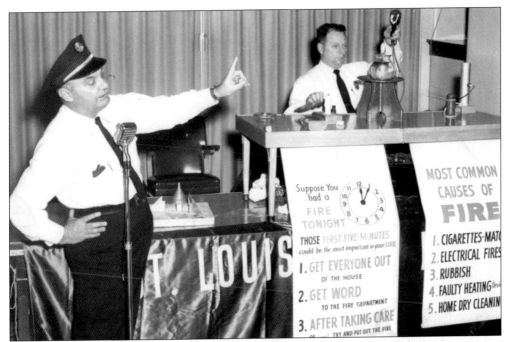

Thomas Godfrey, chief instructor at the training school, and Dave Parshall lecture recruits on the causes of fire.

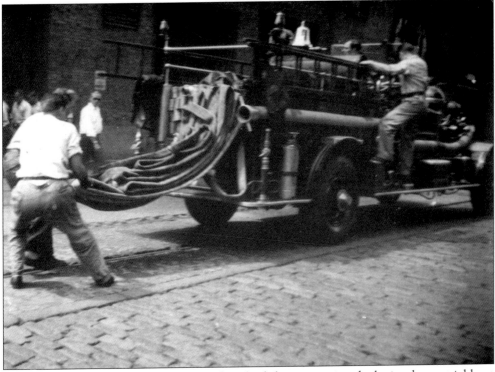

"Lead off!" became a familiar command as firefighters practice deploying hose quickly at the fire academy.

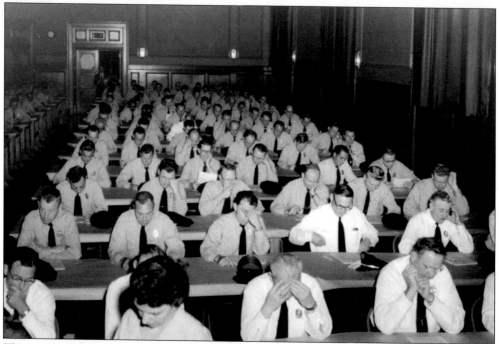

The test necessary for promotion within the fire department is tough, but that has never stopped dozens of applicants from taking it each year.

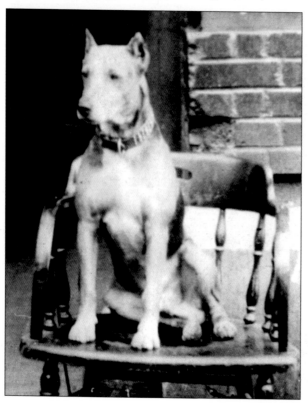

Theodore, the faithful fire dog from Engine Co. 6 at 12 N. Ninth St., waits for the boys to return from a fire.

Five

NEW INVENTIONS, NEW TECHNOLOGY

Firefighting became a science after 1950, with new strategies, techniques, and technologies. One of the most important strategies was fire prevention, and educating the public was key to that. The department used attention-grabbing techniques, such as a Miss Flame contest, rodeos, and programs for children to make the public aware of need for active fire prevention. After 1980, it campaigned for the use of smoke detectors in all city homes, apartment houses, and buildings. After 1950, the union—International Association of Firefighters Local 73—grew strong and fought for shorter hours, medical benefits, and pensions. A half-dozen other organizations, such as the Backstoppers, who provide financial help for families of firefighters killed in the line of duty, the St. Florian Society, and the Box 8 Club showed their support for firefighters.

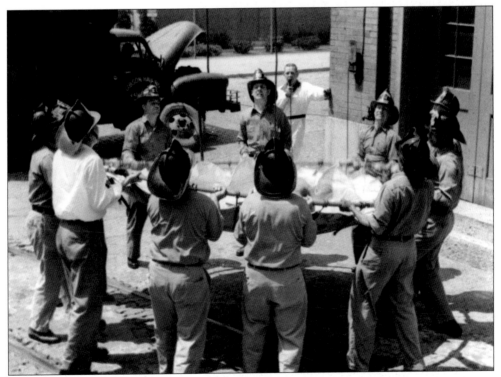

Trainees at the Fire Academy practice with the Life Net.

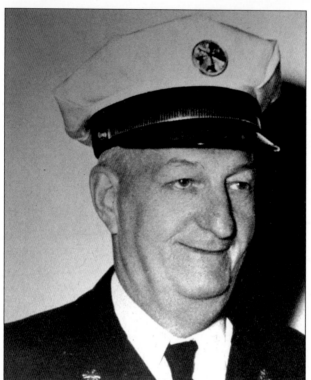

Walter H. Kammann served as fire chief from 1949 to 1955. He joined the department just after the U.S. entered World War I in 1917 and was sent to France with the AEF almost immediately. Back in St. Louis as a firefighter, he survived a building collapse where his helmet was "crushed like an eggshell." The city's first fire marshal, he was considered an expert on fire prevention, and as chief during the Cold War, he worked on the city's civil defense against nuclear weapons.

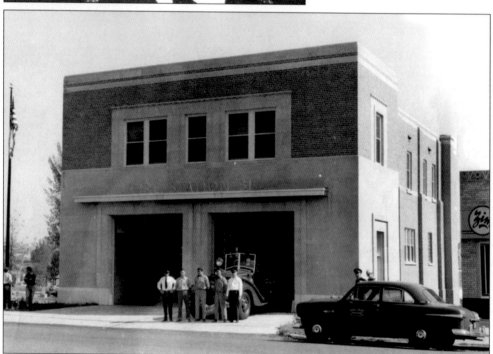

The 1950s was a time of new construction throughout the city. Six new fire stations were built between 1953 and 1957, each a welcome sight to firefighters. This one, which opened in 1953, is located at 4408 Donnovan Ave.

Fireman George Beaumont worked his whole career on Hook and Ladder 15. He was instrumental in starting the canteen services for firefighters, was a Box 8 Club supporter, and was well-known as an excellent photographer.

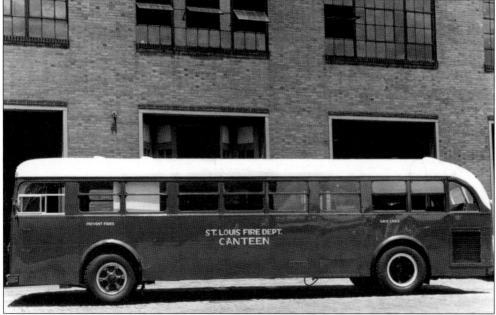

The American Red Cross canteen wagon was operated by the Box 8 Club for years. It brought welcome hot coffee and cold drinks to every major fire and offered firefighters a place to cool down out of the smoke. Later, the Salvation Army took over operation of the canteen and still runs it today. This city bus was rehabbed by the fire department to be used as a canteen.

Hugh F. Lyon, fire chief from 1955 to 1958, had close ties to the profession. His great uncle was Clay Sexton, the city's first fire chief, and his father was also a firefighter. Lyon was the man who pulled Morgan's body from the Goodwill fire while the blaze was still in progress. During Lyon's tenure, the department was divided into nine fire districts housing 43 engine companies, 23 hook and ladder companies, one rescue squad, nine hose wagons, two foam trucks, and two fuel trucks.

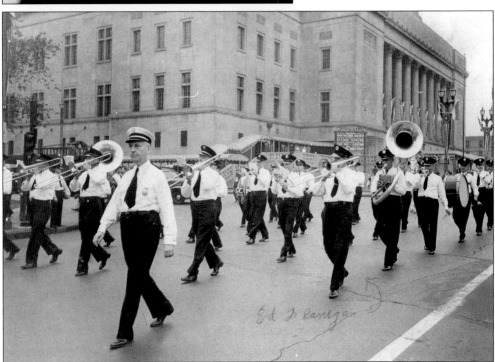

The fire department band marches down Market Street in front of Kiel Auditorium.

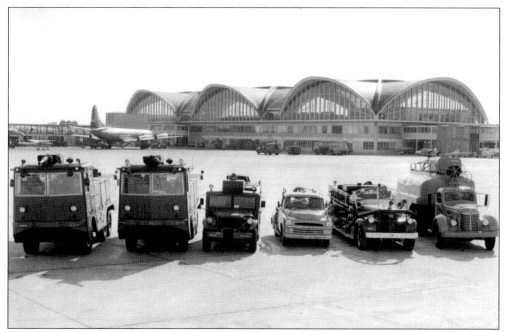

The fire department assumed responsibility for firefighting at Lambert Field—now Lambert International Airport—on January 29, 1958. The force used crash-rescue equipment loaned by the Navy for a few months and then received apparatus from the Air National Guard.

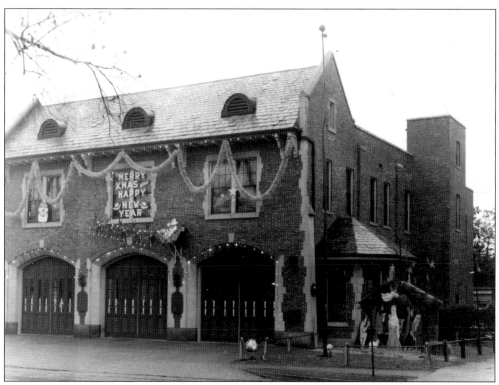

The crew at Engine House 43 at 4810 Enright Ave. enjoyed decorating for Christmas.

After 27 years with the department, James J. Mullen became chief and served from 1958 to 1965, a period of innovation in equipment. The department bought its first snorkel truck and developed the Oklahoma spike, a piercing nozzle.

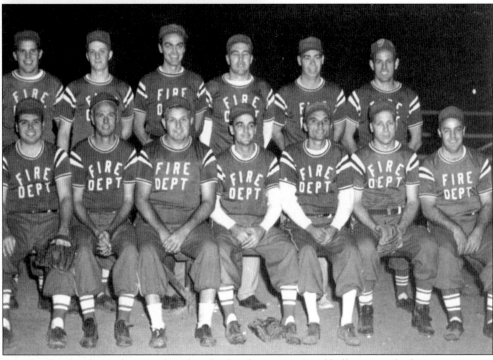

Dozens of enthusiastic players enlisted in the fire department's softball team and other sports teams.

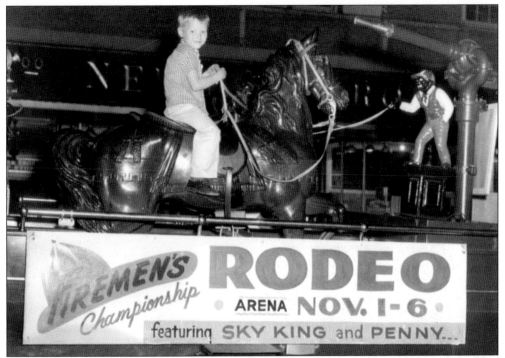

The Fireman's Rodeo, very popular among St. Louisans, brought big name entertainers to town during the 1950s and 1960s. It raised money for the firefighters' pension fund.

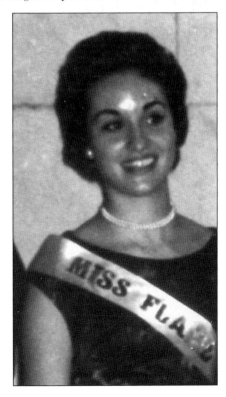

The first "Miss Flame" was Grace Ann Parshall. She helped publicize fire prevention.

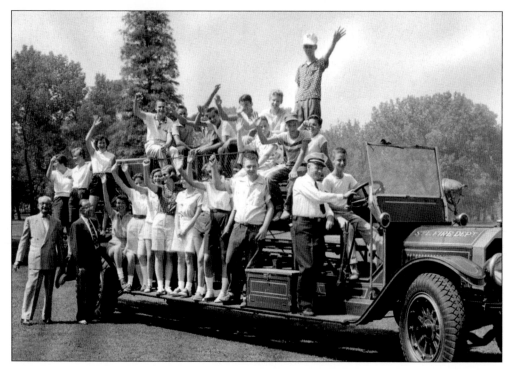

Kids love fire trucks. In the late 1950s, firefighters gave them opportunities to ride. St. Louis firefighters have always welcomed children as visitors to their firehouses. During the city's long, hot summers, they installed street showers to help cool them off. They also frequently helped in Christmas-time toy repair and toy collecting projects.

African-American firefighters organized Firefighters Institute for Racial Equality (FIRE) in 1967 to advocate for full representation in the department. Almost half the force today is African-American. Here the retirement of a veteran firefighter is commemorated.

Stanley Newsome retired at the rank of Deputy Fire Chief. Known as an entrepreneur and developer, he now serves on the Civil Service Commission for the city of St. Louis.

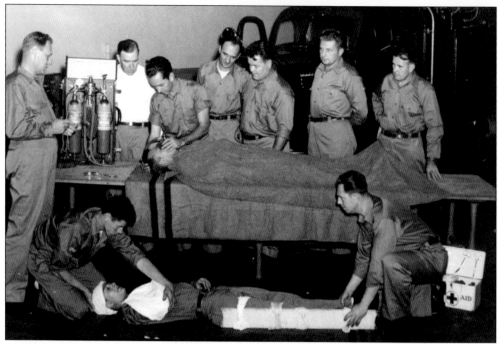

Learning first aid was an important step in becoming part of the rescue squad. Eventually, training was increased to the level of an Emergency Medical Technician.

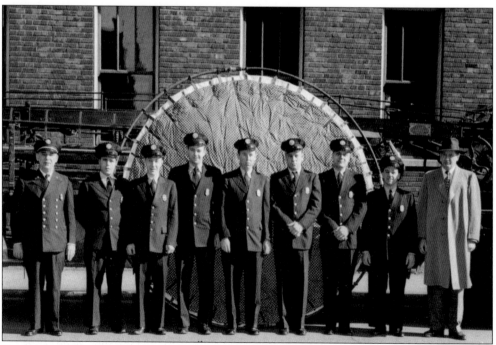

Firefighters from Hook and Ladder 8 pose with the Life Net. They were responsible for saving many lives.

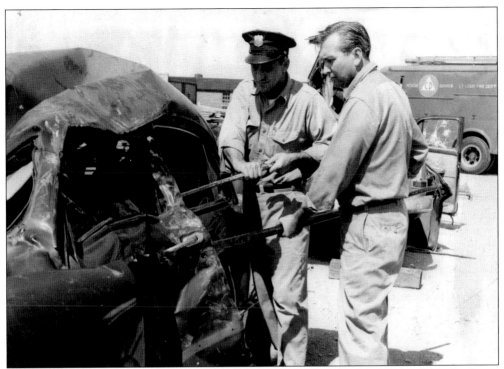

Members of the rescue squad practice forcible entry on a derelict automobile. St. Louis firefighters participate in rescue operations for hundreds of automobile accidents each year.

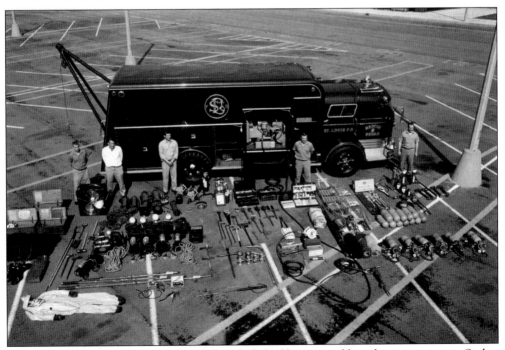

Equipment from the rescue squad c. 1960 included self-contained breathing apparatus, a Stokes basket, extraction tools, a boom, and a chemical suit.

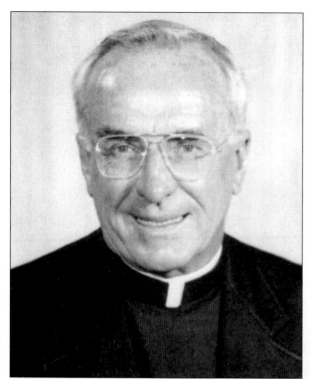

Father Jerry Jakle was the spiritual leader of the St. Louis Fire Department from 1962 until his death on December 10, 1980. He was appointed the official chaplain by then-mayor John Poelker in 1976. Father Jakle originated the annual Mass held at St. Stanislaus Catholic Church (below) for all firefighters and their families. The Mass has been expanded to include the annual award ceremony for both city and county firefighters.

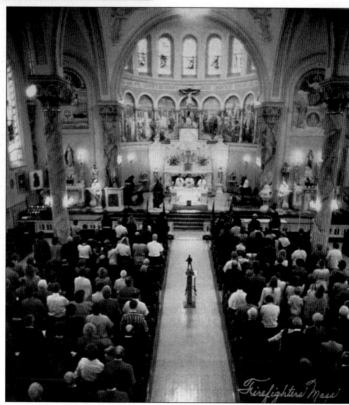

St. Stanislaus interior is seen here.

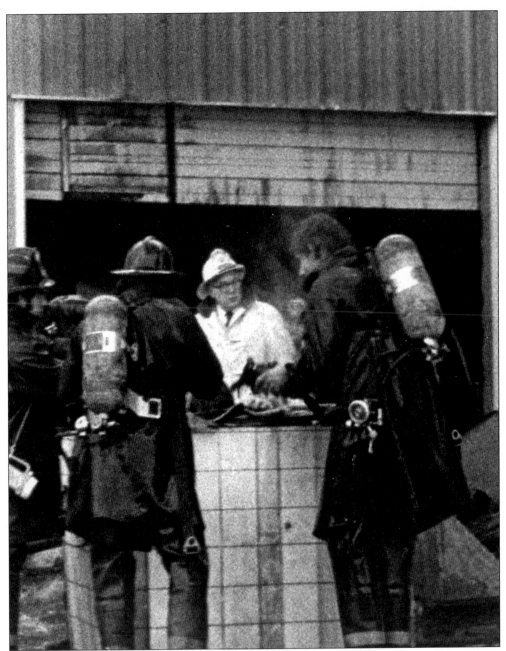

Dr. Marshall B. Conrad was the Medical Director of the St. Louis Fire Department for 21 years. Doc Conrad kept the firefighters fit for duty. Besides his medical practice and serving on many committees for local organizations, he always showed up at multiple alarm fires, such as this one.

Thomas Long served as fire chief from 1980 to 1986, during the period of intense rehabbing of old city homes and apartment houses. Bringing such structures "up to code" was an important part of fire prevention, as was the installation of home smoke detectors. Long's father was a firefighter for 43 years and as a boy, Tom dreamed of being a chief while he was hanging around the station house.

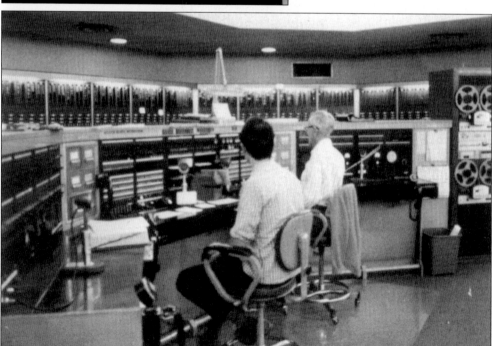

This state-of-the-art communications center was the heartbeat of the department in the 1970s. Communication has become ever more high-tech, keeping up with innovations in the field.

76

Charles Kamprad joined the fire department in 1944 and was promoted to captain, battalion chief, and deputy fire chief before becoming fire chief in 1974. During his tenure, a $3.5 million bond issue was passed to replace the department's old fire equipment and the 911 emergency call system was installed, allowing alarm boxes to be removed from the streets. He coined the department slogan, "justifiably proud."

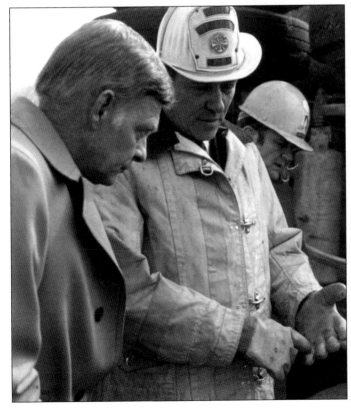

Chief Kamprad explains operations at a major accident involving a truck to a reporter at the scene.

History was made twice on August 28, 1987, when the first female firefighters joined the largest recruit class ever assembled in the Fire Academy. The five women joined 51 men for an intense eight weeks of recruit training. Here Chief Neil J. Svetanics welcomes Gail Simmons, Lori Riley, Claudia Stevenson, Bethany Green, and Anita Stewart to the department.

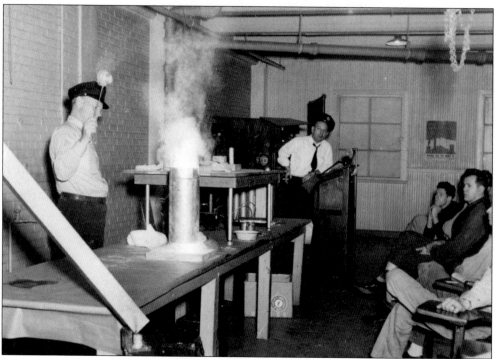

Recruits study fire behavior at a demonstration of a chemical fire in the training academy.

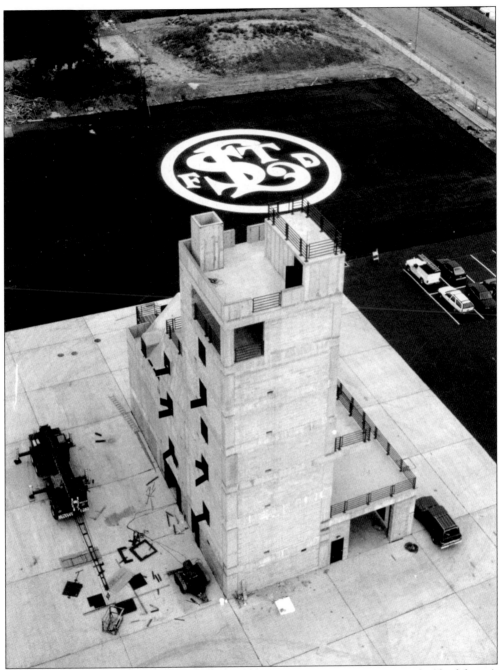

The new Training Academy was designed for the simulation of almost any kind of fire. A landing point for helicopters is behind the structure.

Chief Sherman George joined the fire department after returning from duty in Vietnam. He was an active member of FIRE and other civil rights organizations. After serving as captain and battalion chief, he was promoted to fire chief in 2000, becoming the city's first African-American to hold that office.

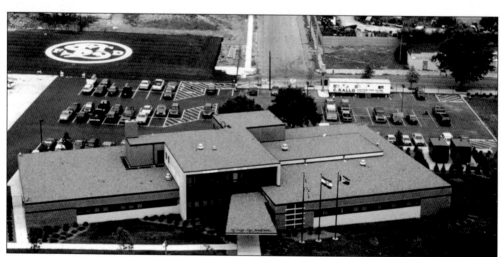

The St. Louis Fire Department Headquarters and Museum is located at 1421 N. Jefferson. Fire Chief Neil Svetanics envisioned the creation of a museum and donated his own collection of fire helmets, badges, medals, and other memorabilia. The museum contains more than 700 artifacts from the late Morton T. Werner's collection, now on permanent loan from the Missouri Historical Society.

Six

SEE YA AT THE BIG ONE!

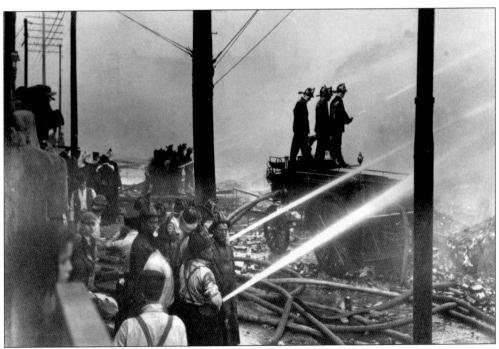

Fires draw spectators just as any epic struggle does. St. Louisans have continually been awed by the professionalism, courage, and stamina of their firefighters in action. Here three firemen stand on the deck of their truck to aim hoses and nozzles at a blaze. The horses have been unhitched and led away to safety.

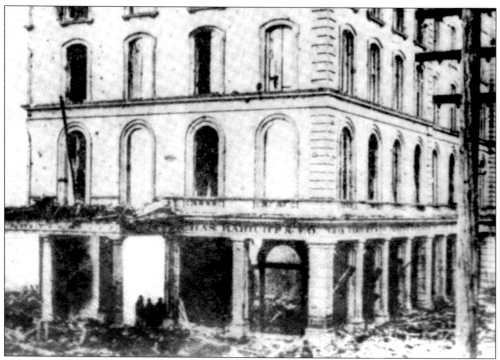

The Southern Hotel was St. Louis' premier hotel in the late nineteenth century.

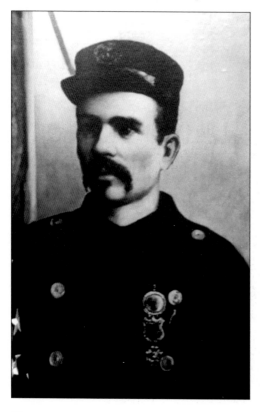

Phelim O'Toole of Hook and Ladder No. 3, is remembered today for his extraordinary heroism during the Southern Hotel fire. The company's 85-foot ladder couldn't reach six hotel maids trapped in a room 100 feet above the pavement. From the edge of the ladder, O'Toole tossed the end of a stout rope up into the room, instructing the young women to tie it around a bedstead. The other end he tied to his ladder and then climbed hand-over-hand the 15 feet up to their window. Once inside, he sent each maid down over the rope to the ladder and thus to safety. The hundreds of bystanders on the ground cheered as each woman, some nearly overcome with smoke, climbed down the ladder into the waiting arms of a fireman. O'Toole was the last one out and only minutes later the wall collapsed. He was known for other heroic exploits. When the courthouse dome was on fire, he clambered to the top cornice, cut through the roof, and extinguished the flames. He was killed in the line of duty on July 6, 1884, at the age of 36. His funeral, held at the Old Cathedral, was one of the largest in St. Louis history.

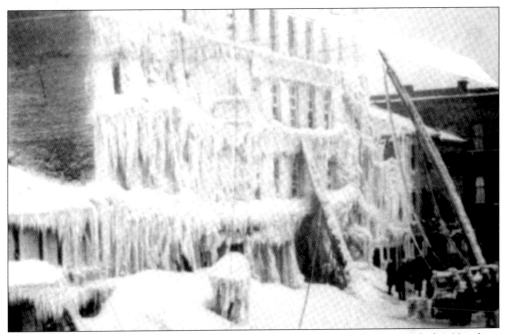

It was minus 26 degrees when firemen were called to a blaze at the St. Nicholas Hotel on January 4, 1884. Water from the hoses instantly froze and the walls of the hotel became coated with two feet of ice from. The aerial ladder was abandoned after being covered with tons of ice.

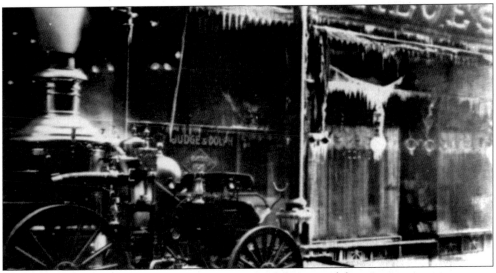

A steamer works a fire at the Aloe Company around the turn of the century.

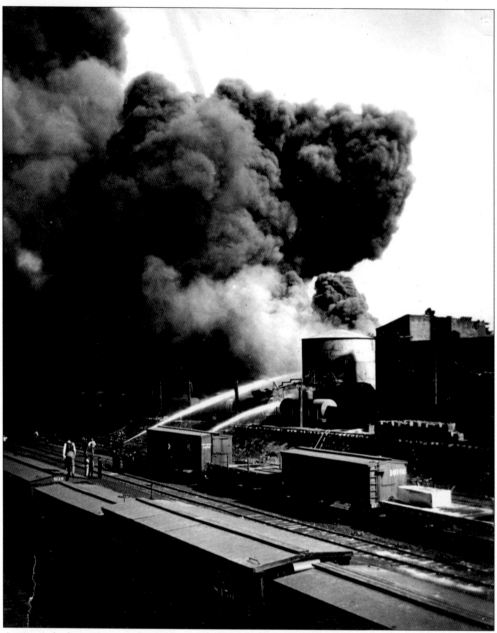

A general alarm fire at the Waters and Pierce Oil Company in 1892 at 13th and Gratiot brought out all available equipment. A fire at the same facility in 1910 resulted in the death of fire captain. While the captain was direction operations, an explosion occurred, causing a mass of brick and mortar to crash upon him.

A disastrous fire at the American Tent and Awning Co. at Third and Chestnut occurred on the night of February 3, 1902. The brick walls collapsed, killing seven firemen and injuring several more, including Chief Swingley.

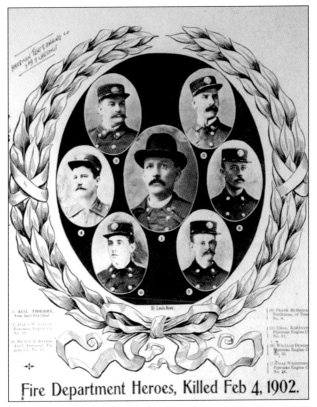

Fire Department Heroes, Killed Feb 4, 1902.

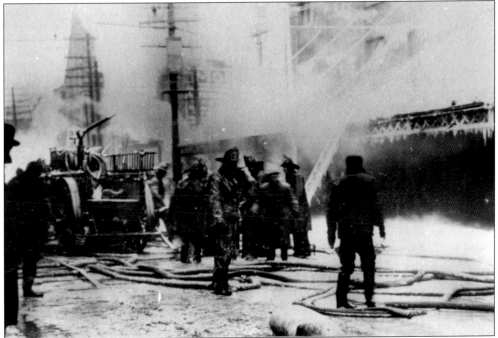

A 1905 fire at a milling company brought out a combination hose and chemical truck with deck pipe and 1,000 feet of 2 1/2" hose.

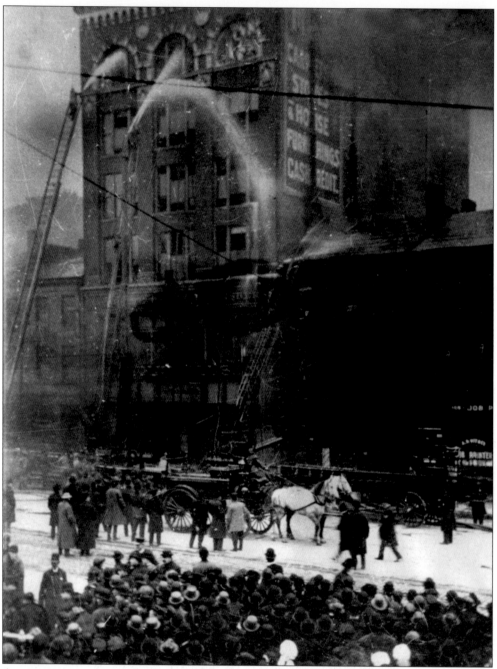

Apparatus responding to the Mulvihill Furniture Co. fire in 1910 during a snowstorm included an 1892 Steck, a Holloway hose wagon, and a 65-foot Hale tower. Hook and Ladder 8's large aerial is visible in the center of the picture, clearly broken.

Flames were discovered in a freight elevator at Christian Brothers College at 7 a.m. on October 5, 1916. The 200 students were evacuated at once, as the flames spread along the woodwork. The water supply in the standpipe was quickly exhausted and when the first pumpers arrived they found no hydrants on the property. By the time hoses were connected to hydrants on the next block, the college was almost gone. Chief Henderson left the scene when he felt the fire was under control, and at that time, no men were in the building. Someone ordered them back in and the wall collapsed, killing six men and injuring several others.

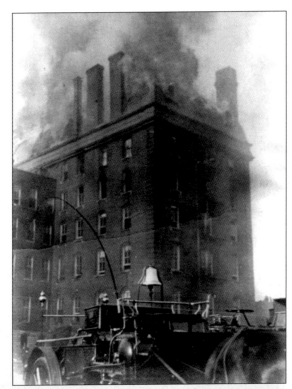

Hundreds of cars took part in the funeral procession for six firemen killed in the Christian Brothers College fire at Kingshighway and Easton. The procession assembled at Engine House 50 at 223 S. Newstead Avenue, where Hook and Ladder 19 was located. That company lost five of the six firemen killed.

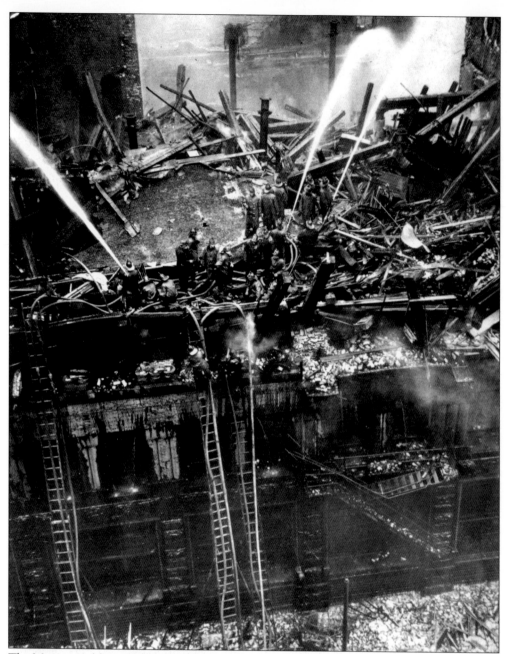

The Missouri Athletic Club fire was the worst single-building fire in St. Louis history. It began at 1:45 a.m. on March 8, 1914, in the club dining room on the third floor. When the first engine arrived, the seven-story building was already a fiery furnace. Thirty-seven men, mainly members of the club, died and scores were injured. The *Globe-Democrat* reported that "fire escapes were useless in the seething mass of flame." The morning after the Missouri Athletic Club fire shows the total destruction of the building. Later in the day the ruins collapsed, killing seven sightseers.

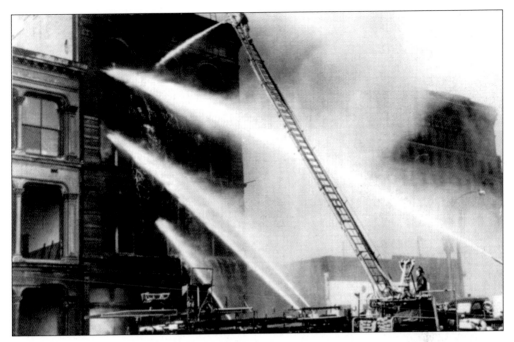

St. Louis firefighters have battled many downtown blazes using multi-story ladders.

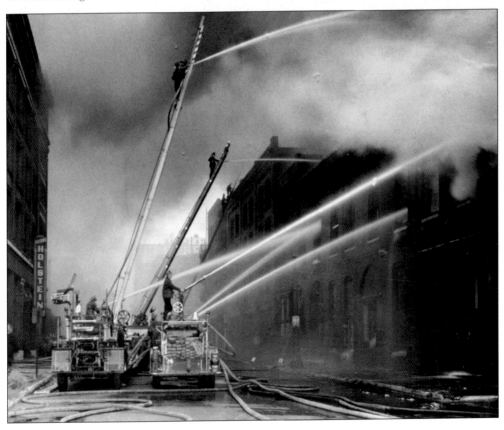

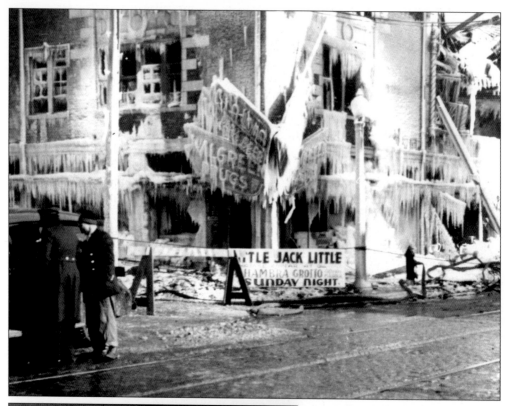

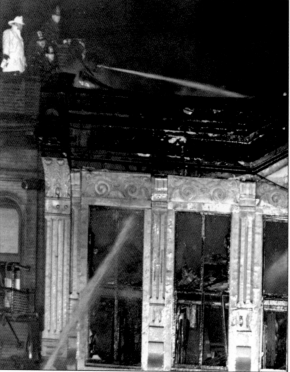

The Casa Loma Ballroom at Cherokee and Iowa was one of the most popular night spots in the city through the Big Band era of the 1930s. It burned on the afternoon of January 19, 1940, along with the Cinderella Bowling Lanes. Twenty-one engines, 11 hook and ladders, and 200 firemen fought the blaze in record cold, and most of the city's apparatus turned out. Twenty men were injured.

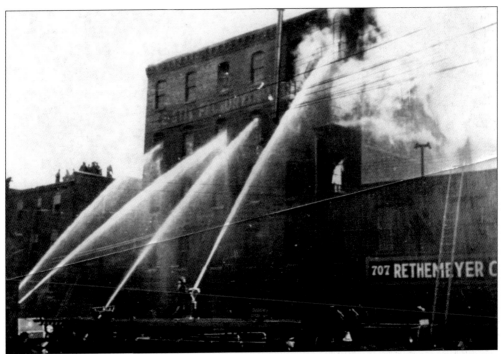

A fire raced through Goodwill Industries at 713 Howard St. on March 20, 1943. Fire Chief Joseph Morgan stood on a fire escape at the second-floor level (in white coat) calling to his men to abandon the building when the wall fell. He was killed instantly, buried under the debris. Nine other firemen were injured.

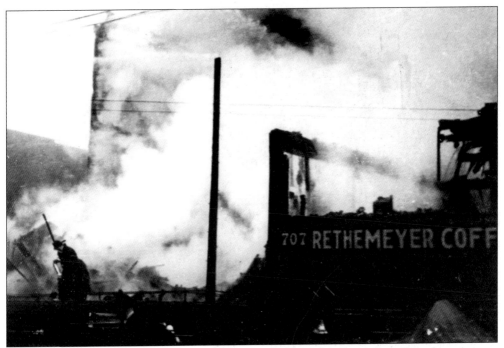

This photograph was taken at the Goodwill fire moments after the walls collapsed.

At about 2:30 p.m. on July 19, 1963, a fire started in the basement of the Highland's restaurant. The popular amusement park at 5600 Oakland quickly emptied, as the wind whipped flames through the Flying Turns, the arcade building, fun house, and Ferris wheel, destroying everything. The roller coaster is still standing at right.

The roller coaster at the Highland's goes up in flames.

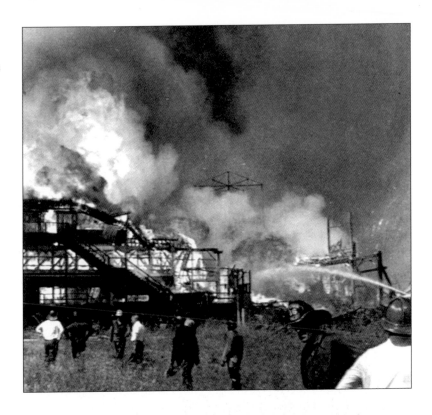

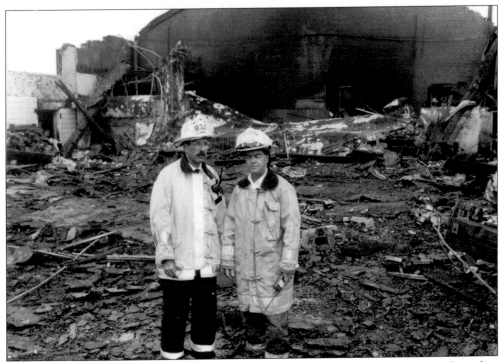

Frank Schaper and Mike Donovan stand in the ruins of the St. Mary's School gym after a fire.

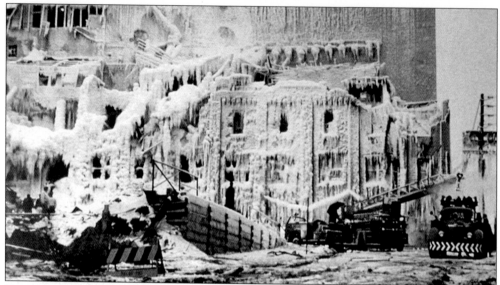

Dust in a grain mill at Ralston-Purina exploded at 3:20 p.m. on a bitterly cold afternoon on January 11, 1962. The blast, which seemed like "the end of the world" to one witness, set off a five-alarm fire. Three people died and 41 were injured. Fire Department captain Roy Simpson, collapsed and died of an apparent heart attack while at the scene, and five other firemen were hospitalized with injuries. Only hours later, a building at Gaslight Square went up in flames and the weary fireman had to respond in full force.

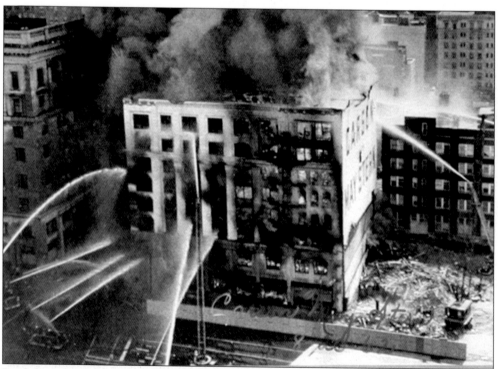

Firefighters battled a spectacular multi-alarm fire in the Carson-Union-May-Stern Building at 12th and Olive on August 20, 1962. Thirteen firemen were injured.

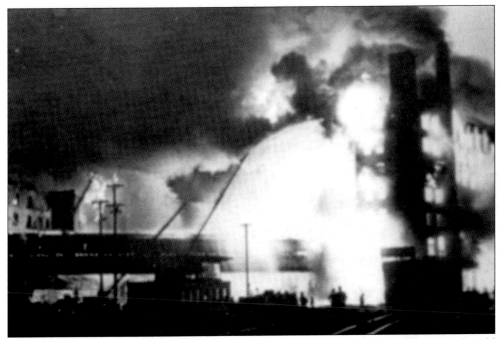

A raging fire swept through an area of two square blocks early on August 5, 1965, in the old Cupples complex just west of Busch Stadium. Several buildings were destroyed in the general alarm blaze bounded by 7th to 9th Streets and Spruce to Poplar.

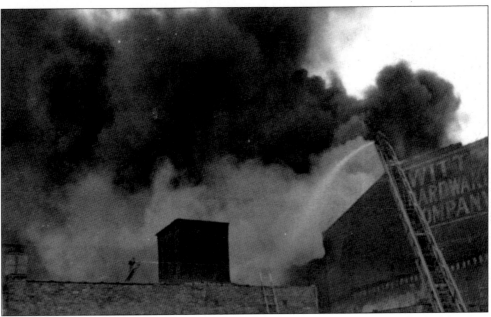

A five-alarm fire destroyed the century-old Witt Hardware on Dec. 7, 1967. The building was located at 706 N. Third Street.

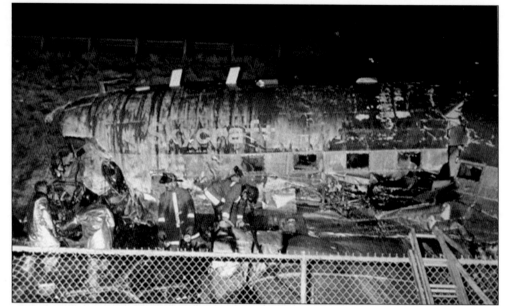

A 58-ton Electra L-88 cargo plane crashed on takeoff at Lambert International Airport shortly before midnight on July 7, 1977. Three crew members were killed. A witness explained, "The plane started to fall and the pilot pulled the nose up when [it] just blew up." The airport firefighters, along with those from Bridgeton and elsewhere, immediately converged on the scene and kept the flames from spreading to the nearby neighborhood.

Four command officers work a multi-alarm fire in North St. Louis. From left to right are Deputy Chief Bob Brewer, Battalion Chief Frank C. Schaper, Battalion Chief David G. Weman, Fire Chief Neil J. Svetanics.

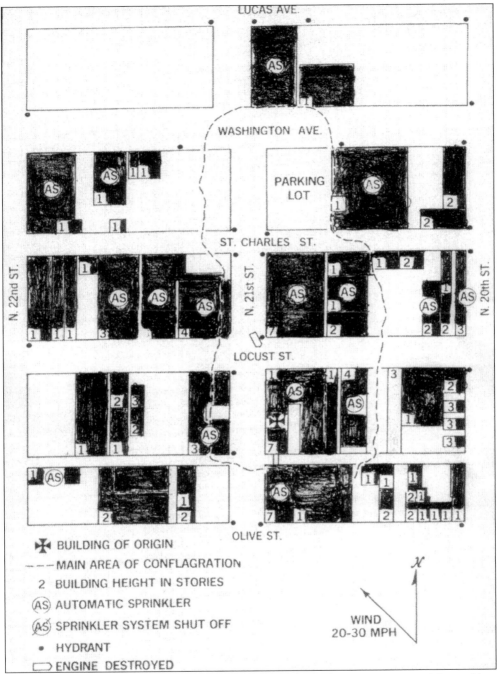

LUCAS AVE.

WASHINGTON AVE.

PARKING LOT

ST. CHARLES ST.

N. 22nd ST.

N. 21st ST.

N. 20th ST.

LOCUST ST.

OLIVE ST.

✠ BUILDING OF ORIGIN

– – – MAIN AREA OF CONFLAGRATION

2 BUILDING HEIGHT IN STORIES

(AS) AUTOMATIC SPRINKLER

(AS) SPRINKLER SYSTEM SHUT OFF

• HYDRANT

▭ ENGINE DESTROYED

𝒳

WIND
20-30 MPH

Downtown St. Louis escaped disaster on April 2, 1976, when a firestorm was ignited from a blaze in a seven-story building on the corner of Locust Ave. and 21st Street. The fire burned out of control through several blocks for three hours, taxing firefighters to their fullest. Every engine and most of the city's ladder trucks were tied up in the main fire or spot fires caused by flying brands. The fire was stopped only when it reached several natural breaks. Property loss was in the millions, eight firefighters were injured and one pumper was completely destroyed. Chief Kamprad recalled that the winds created by the conflagration were so strong they blew firefighters off their feet.

Less acclaimed than the soldier, the fireman leads a more strenuous life and faces death more frequently. But "peace hath her victories no less renowned than war," and victories of peace achieved by the firemen are his own best reward, though he should have a fuller need of appreciation and support from the public he serves fearlessly, loyally, faithfully.

Officers and Members
of the
St. Louis Fire Department
Killed in the Line of Duty
May Their Loyalty, Courage and Sacrifice
Be an Inspiration to All Firefighters

Alber, Edwin Wm. (Batt. Chief)	Frankel, Frank (Captain)	Larkin, Patrick	Rogers, George I.
Anderson, Thomas	Gannon, William	Lauth, Fred	Roland, James
Bartold, John	Gavin, John (Captain)	Lebbing, Henry	Ruetz, William
Beckman, Walter (Lt.)	Geisler, Robert	Letson, Benjamin (Captain)	Rychlink, Frank J.
Biggins, John	Georgeton, Frank J. (Captain)	Lorbert, Clifford (Captain)	Saunders, Edward
Blake, Raymond W. (Captain)	Gerschke, Frank	Lowe, Charles	Schimper, Joseph
Blankenship, Elby (Captain)	Gottwald, George	Lynch, Daniel (Lt.)	Schleifstein, Ervin (Captain)
Born, Edward	Grady, William	Lynch, Martin (Captain)	Schmitt, Charles
Bowers, Henry	Gray, Arthur	Lynch, Michael	Shannon, Russell
Bridge, John	Green, Edward (Lt.)	Lynn, Abraham	Shivley, Benjamin (Lt.)
Bruer, George	Green, James	Lyons, Michael (Captain)	Shockey, John (Batt. Chief)
Budde, Henry (Lt.)	Greiser, William E., Jr.	Mansfield, Nicholas	Siebert, George
Buder, Frank	Grewe, Edward	Marik, Charles	Simpson, James B.
Card, Albert (Lt.)	Guentert, Joseph	Mayer, William	Simpson, Roy (Captain)
Canavan, Thomas	Guiney, Jeremiah	McBride, Frank (Lt.)	Smith, B.M.
Cannell, Frank	Haas, John	McCall, Ralph R.	Smith, George (Captain)
Carey, Michael	Hacker, Dan (Captain)	McCarthy, Cornelius	Staunton, John (Captain)
Carroll, Henry	Hade, John	McDonald, Frank	Steele, Daniel (Captain)
Carten, Eugene	Hamilton, Robert S.	McKernan, Bernard (Captain)	Stevenson, James
Concannon, Martin	Hanlon, Martin	McNulty, James	Stritch, Michael
Conway, Phillip	Helbig, Oliver A., Sr.	Mebus, Charles	Sturmfels, Aug.
Craig, John H.	Hesse, John	Miller, John D.	Styer, John
Crider, Howard B.	Hines, Owen	Miller, William	Sweeney, John (Captain)
Crump, Bernard	Hippler, Fred	Morgan, Joseph W. (Chief)	Taber, Elmer T.
Dace, Sylvester	Hoell, Christ (Captain)	Mullery, William F. (Captain)	Tasche, Harry
Dauber, George	Hoffman, Aug. (Lt.)	Nation, William H.	Thierry, Aug. (Deputy Chief)
Devine, George	Hofstetter, Albert (Captain)	Nester, Charles	Thompson, Joseph (Captain)
Diehl, Edward B.	Hummel, Jacob	Niessen, Frederick	Tiff, Frank R. (Batt. Chief)
Doerr, Frederick	Johnson, Edward W. (Batt. Chief)	O'Brien, John F. (Captain)	Titsworth, James E.
Dressel, John	Jones, Frank C. (Captain)	O'Connell, Dave (Captain)	Trzecki, Steve
Dundon, William	Kaltenthaler, Jacob	O'Conner, Thomas	Wand, William (Captain)
Dunsford, Frank J. (Batt. Chief)	Kamer, Melvin	O'Donnell, Owen	Waters, Michael (Lt.)
Eckert, William F.	Kane, Michael (Lt.)	O'Gorman, Eugene	Werminghaus, Frank (Captain)
Egenreither, William	Kehoe, Michael (Lt.)	O'Niell, Hugh J.	Westenhoff, Charles
Fahey, Frank (Batt. Chief)	Kelly, Thomas (Lt.)	Ost, Eugene	Wittgenstein, Joseph
Fernan, George	Kelly, Thomas	O'Toole, Phelim	Wolf, George (Captain)
Fette, Arthur S. (Captain)	Kidney, Thomas	Offenstein, Charles	Woods, Lorenz
Finnegan, Thomas	Koerster, Charles	Parshall, John	Young, George (Lt.)
Fitzgerald, Frank	Krenning, Charles	Paschang, Clarence H.	
Flanagan, James (Captain)	Kuhnert, William F.	Phillips, August	
Foley, William	Kussman, Frank (Captain)	Reichelt, Charles (Lt.)	

Additions to this list of officers and men killed are Derek Martin and Robert Morrison, who died in 2002. It was recently discovered that Ernest Fark was missing from the list. He was killed in the line of duty on December 10, 1949.

Seven

HERE COME THE ENGINES

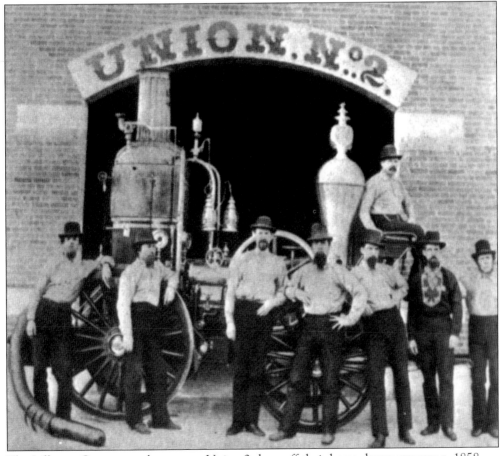

The Jefferson Company volunteers at Union 2 show off their horse-drawn steamer *c.* 1858.

Light, durable hose carts, such as the one on display at the St. Louis Fire Department Museum, were pulled by a dozen firemen, rather than by horses.

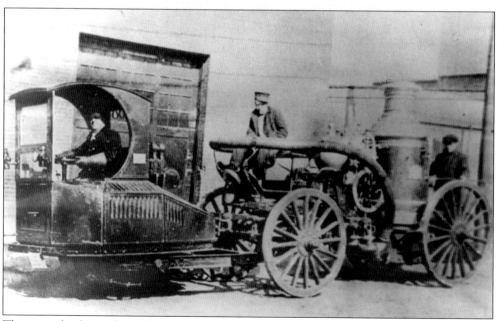

This one-wheel "autohorse" tractor was devised by ingenious mechanics.

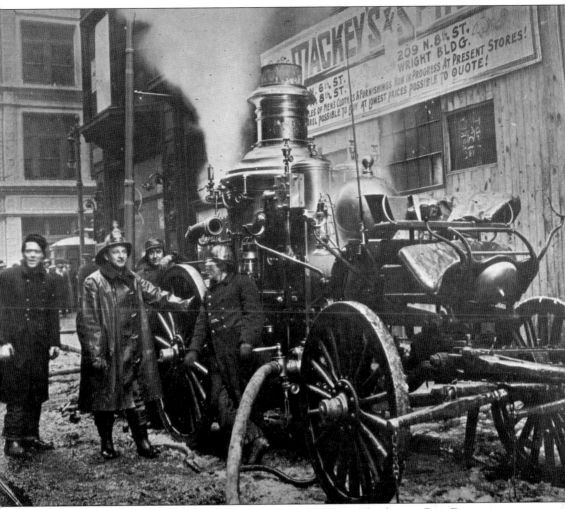

A steam pumper is seen here working downtown around 1905. The famous Barr Department Store is in the background.

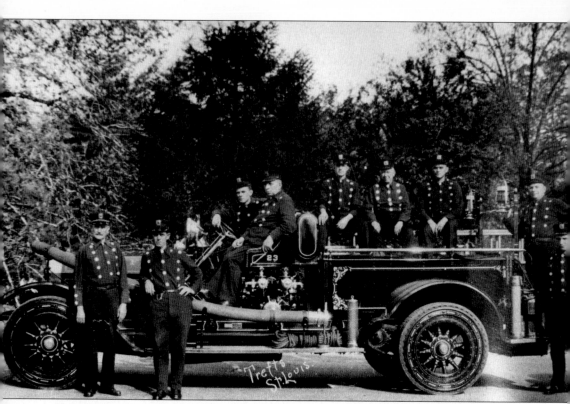

Engine Company 23 is seen here fully loaded with its crew.

Water tower No. 1, is shown here in 1927.

This photograph shows a city service Webb truck.

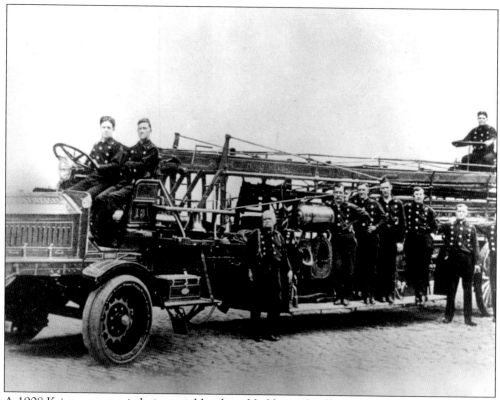

A 1908 Kaiser pneumatic hoist aerial hook and ladder with tiller is seen here.

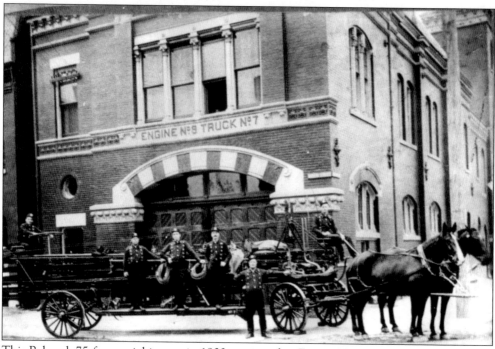

This Babcock 75-foot aerial is seen in 1900, stationed at Engine House 9.

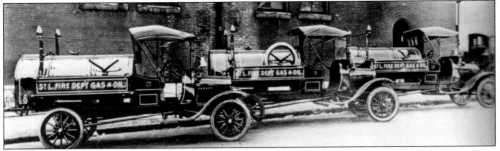

Fuel wagons are seen here in the 1920s.

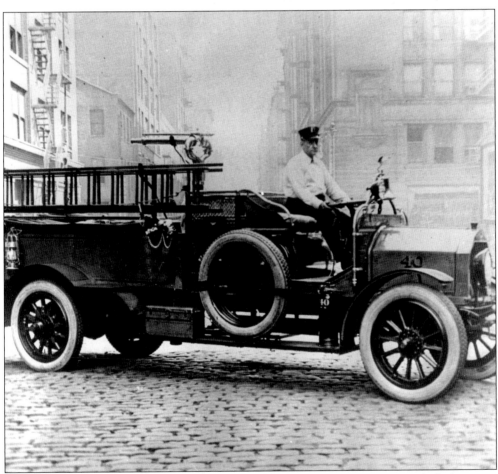

Engine Company 40's 1917 Dorris, model IBW, with hose and chemical with deck pipe is pictured here.

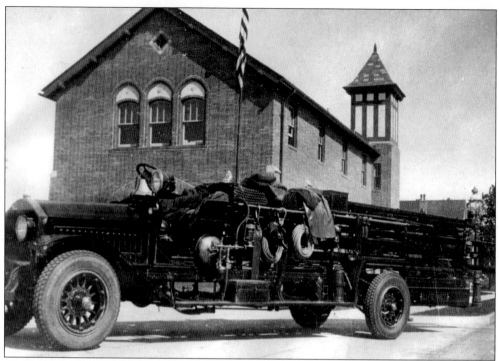

This Robinson, 6-cylinder, 35-gallon chemical truck was assigned to Hook and Ladder 20 in 1917.

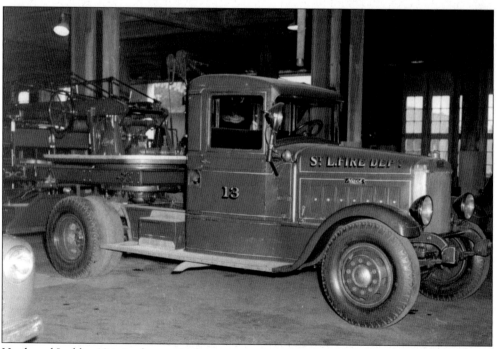

Hook and Ladder 13 is in the repair shop.

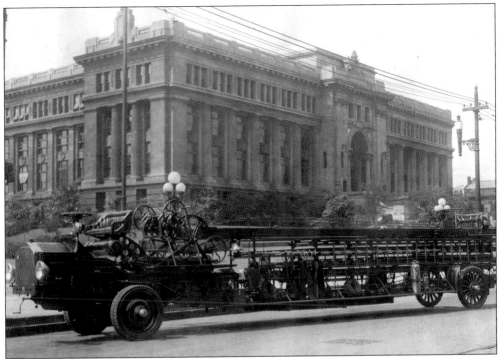

American LaFrance type 31, an 85-foot aerial, of Hook and Ladder 13.

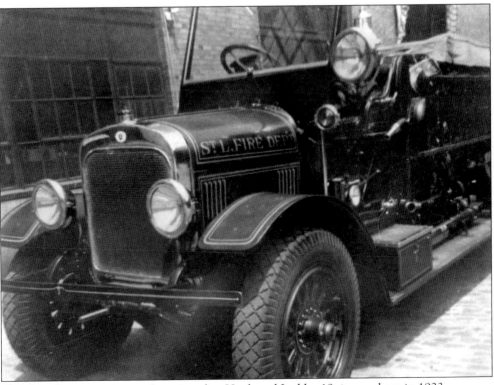

This 4-cycle city service truck, assigned to Hook and Ladder 19, is seen here in 1923.

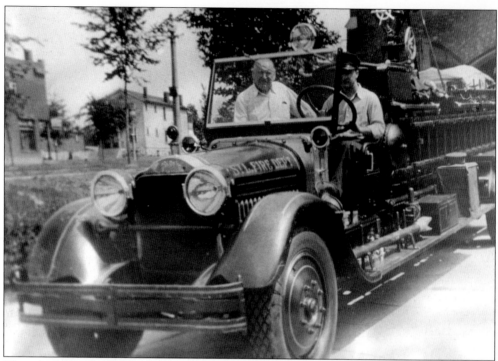

This white bus chassis, pictured in 1924, carried 265 feet of ground ladders.

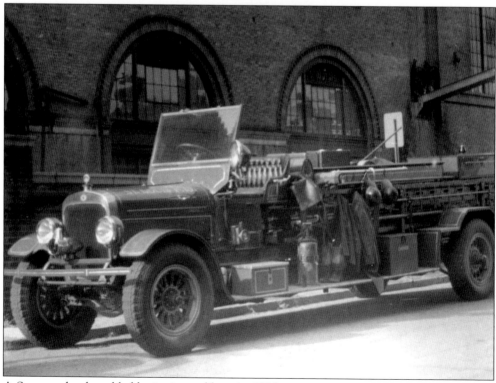

A Seagrave hook and ladder is pictured here in 1925.

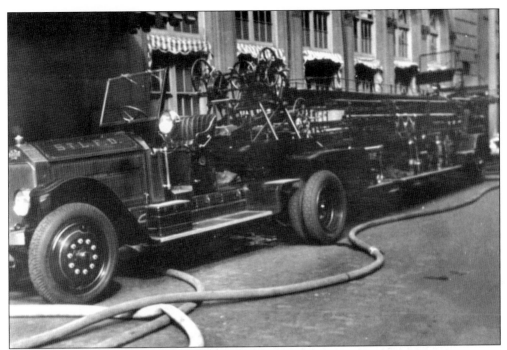

An American LaFrance, 85 foot, spring-hoisted aerial with 349 feet of ground ladders is seen in this 1928 photograph.

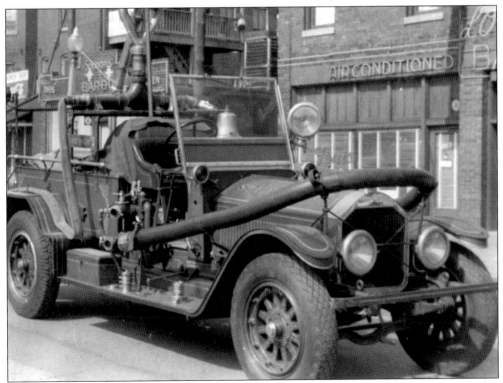

An American LaFrance, 750 gpm pumper, from Engine Co. 27 is pictured in 1921.

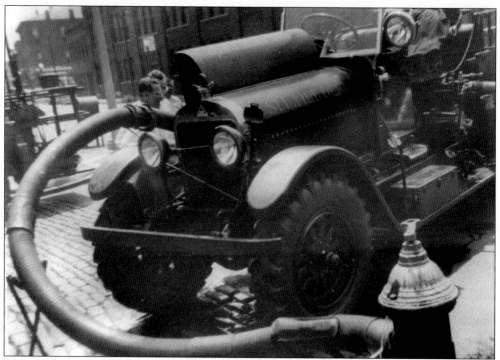

This is a Stutz 750 gpm pumper with squirrel tail hose.

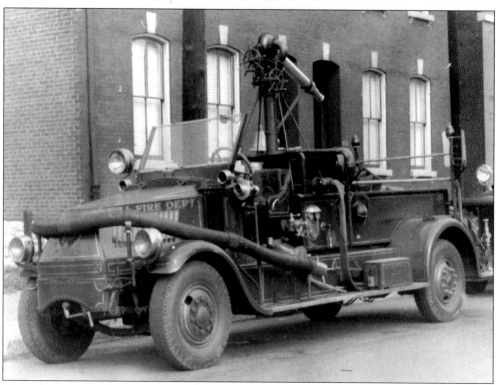

A Mack 750 gpm pumper, of Engine Co. 49, is seen here in 1928.

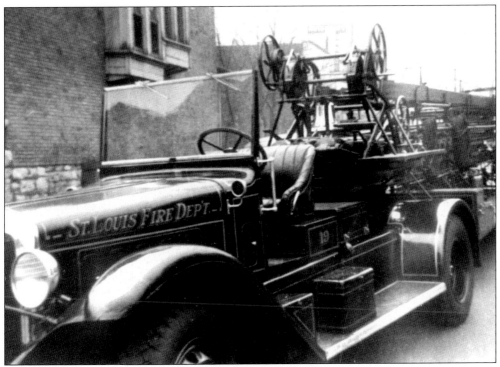

A Sterling tractor, Hook and Ladder 19, in 1931 is seen here.

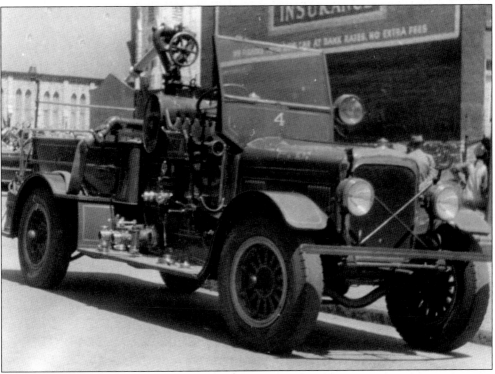

A Seagrave 6CF, 1000 gpm pumper, of Engine Co.12 is shown in this 1927 photograph.

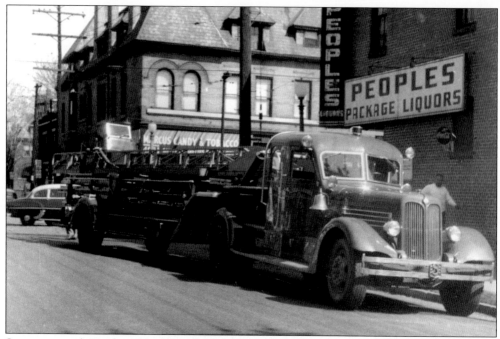

Seagrave aerial, Hook and Ladder 15, as it looked in 1941.

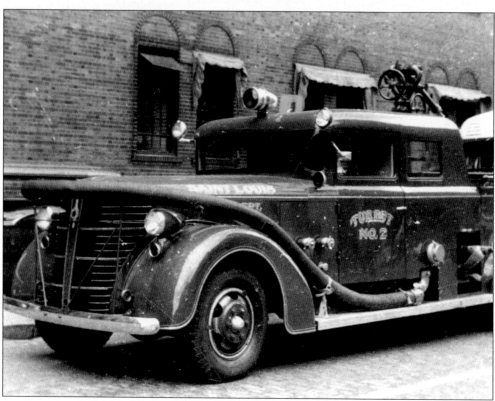

An American LaFrance, Turret Wagon No. 2, is pictured here in 1942.

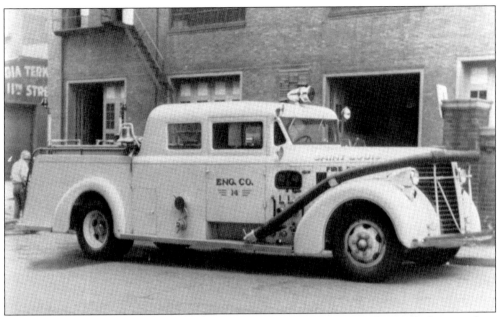

An American LaFrance 1,000 gpm pumper, Engine Co. 14, is seen in this 1942 photograph.

This 1$\frac{1}{2}$ ton Rescue Squad truck with GM chassis worked in the mid-1930s.

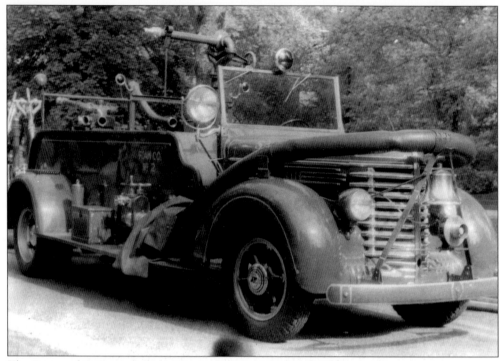

The Diamond T Central, Foam Wagon 2, as it looked in 1942.

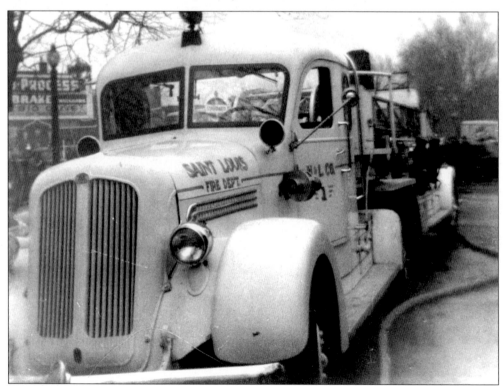

Hook and Laddre 1, c. 1942, was one of two hook and ladders painted white.

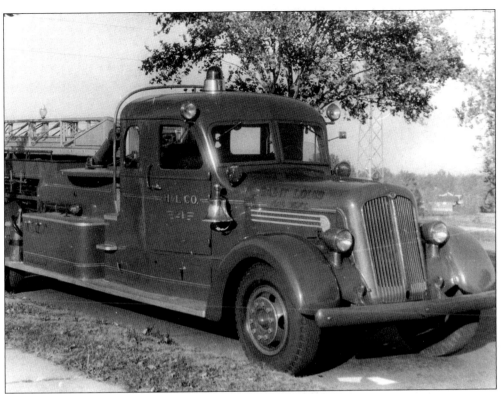

Seagrave Hook and Ladder 21 is seen here in 1944.

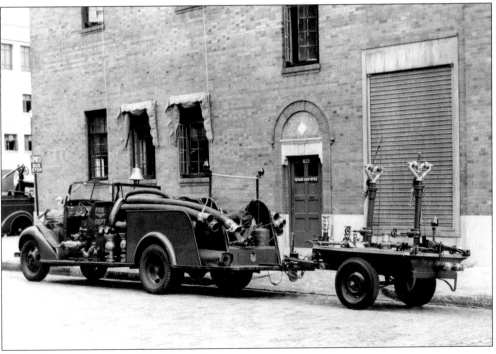

This Siphon wagon was originally an airport pumper.

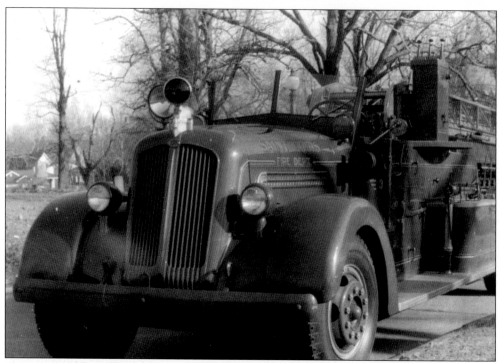

A Seagrave with 287 feet of ground ladder, of Hook and Ladder 3, pictured in 1945.

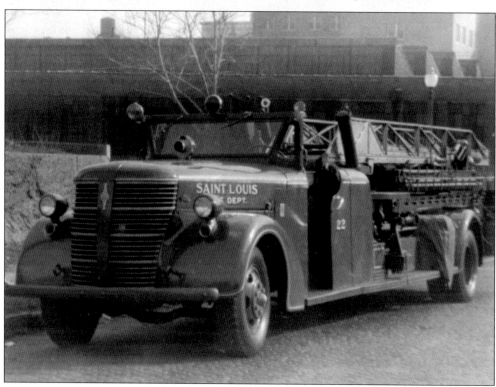

An American LaFrance, of Hook and Ladder 22, is seen here in 1944.

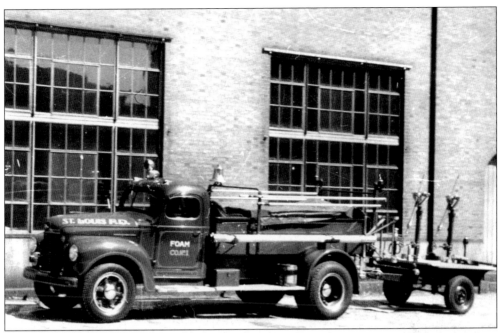

An International Model K8, Foam Truck 1, is seen here in 1945.

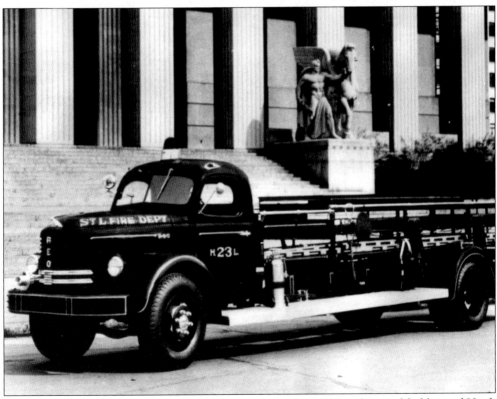

This 1949 photo shows a REO city service truck, with 194 feet of ground ladders, of Hook and Ladder 23.

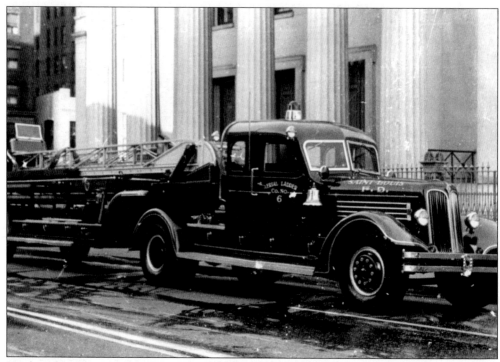

Hook and Ladder 6 in seen here in front of the Old Courthouse.

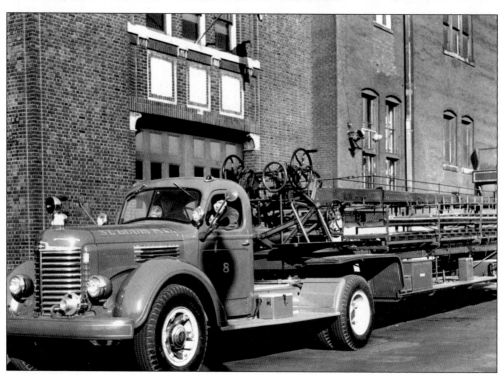

This 1948 photo shows an American LaFrance with an 85-foot spring hoist, of Hook and Ladder 8.

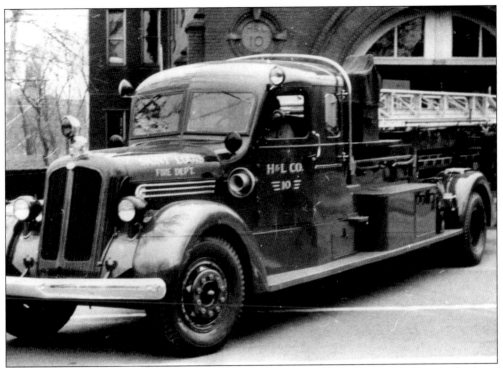

This Seagrave aerial, photographed in 1943, of Hook and Ladder 10, is seen in front of Engine House 35.

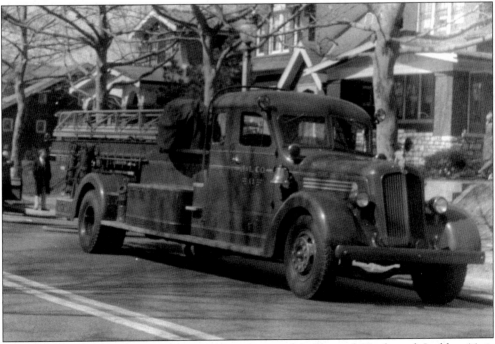

A Seagrave 65-foot aerial with 287 feet of ground ladder, of Hook and Ladder 11 is pictured in 1944.

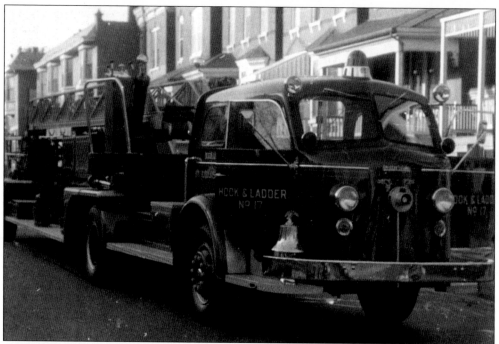

This 1956 photo shows an American LaFrance with an 85-foot aerial and 194-foot ladder, of Hook and Ladder 17.

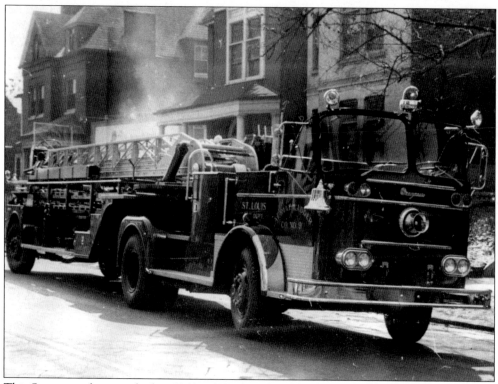

This Seagrave, photographed in 1962, of Hook and Ladder 9, had a 100-foot aerial.

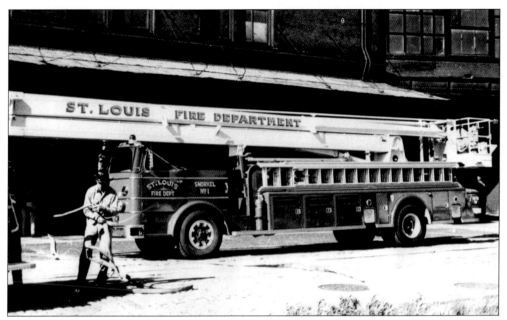

This Pitman, seen here in 1963, had an 85-foot snorkel, and was the first in the department.

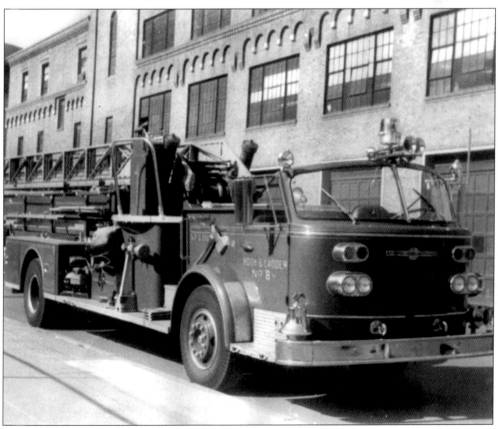

This American LaFrance, with a 100-foot aerial, of Hook and Ladder 8, was photographed in 1968.

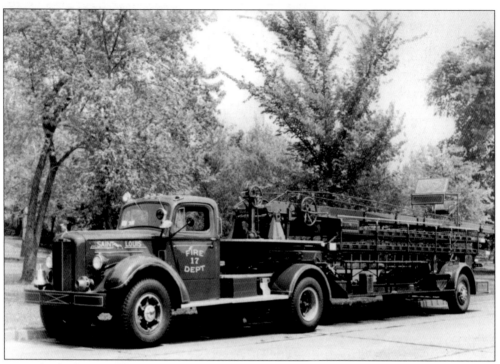

A Mack aerial with tiller, of Hook and Ladder 17, is seen here in 1953.

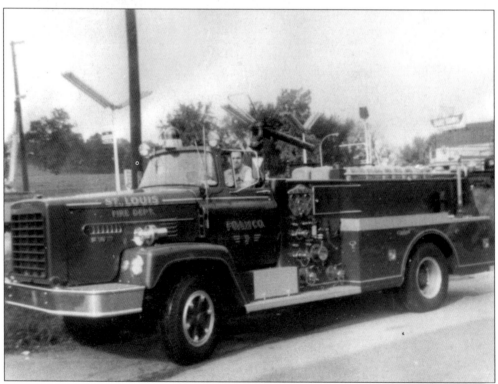

FWD Central, 1000 gpm pumper, Foam Wagon 2, is seen here in 1964.

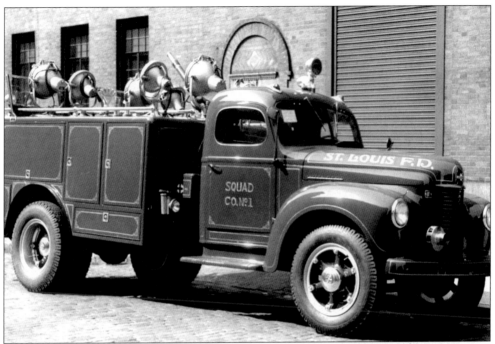

This 1966 photo shows an International Model K8, of Rescue Squad No. 2.

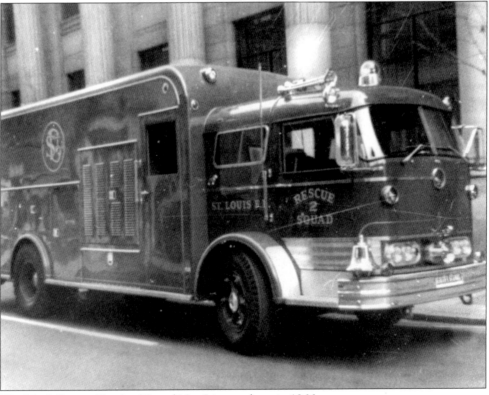

The Mack Rescue Truck of Squad No. 2 is seen here in 1966.

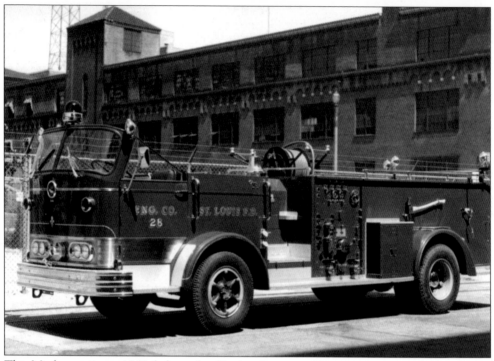

This Mack pumper, *c.* 1962, belonged to Engine Company 30

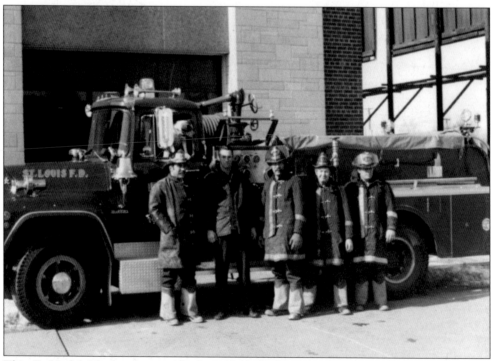

This R Model Mack, photographed in 1968, had a1000 gpm pumper, and belonged to Engine Company 30.

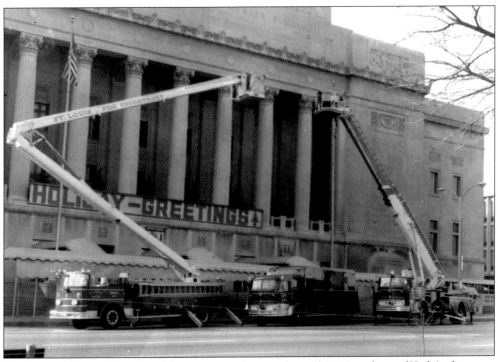

The Snorkel, Rescue Squad, and Scope are seen here in the mid-1960s in front of Kiel Auditorium.

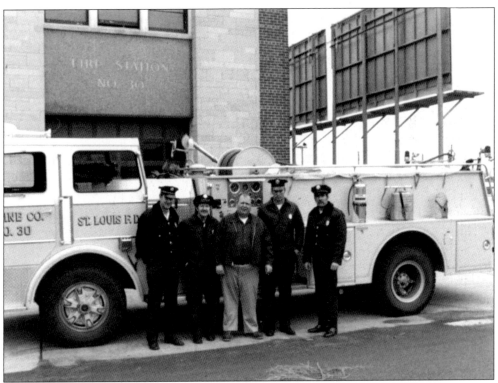

This 1977 photo shows a Howe, 1250 gpm pumper painted yellow, of Engine Co. 30.

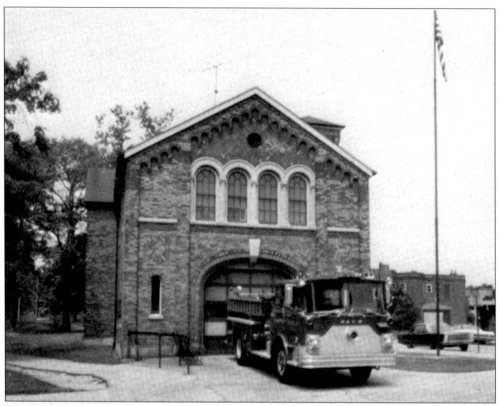

A Mack 1000 gpm pumper is seen here at Engine House 8.

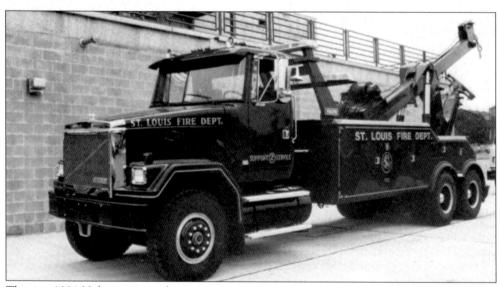

This is a 1991 Vulcan tow truck.

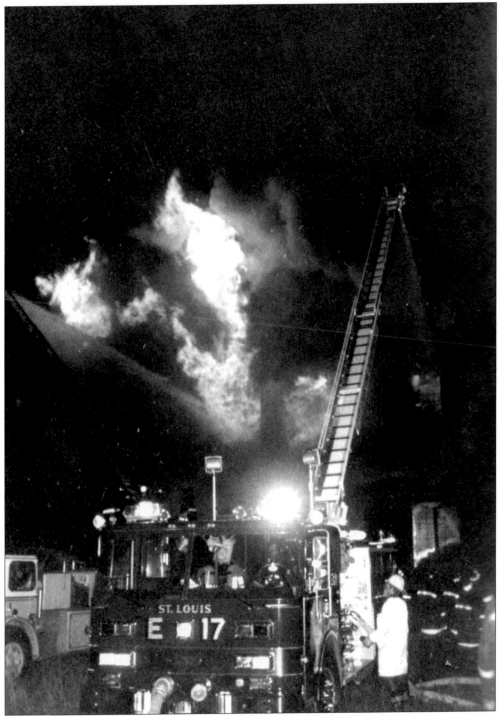

Engine 17 was part of St. Louis' Total Quint Concept, devised by Neil Sventanics. This company rescued a man from a burning roof shortly after being placed in service. It was the first Quint rescue.